Tobias Rehberger
Private Matters
Whitechapel

jrp|ringier

The Whitechapel offers the follo

Large print or audiotapes of Whitechap
Visual description tours by Gallery staff
Magnifying glasses
Guide dogs can be left at the informati
Induction loop in the auditorium
Disabled toilet
Wheelchairs available for your visit
Portable stools
Access to all areas of the Gallery via lif

UP ON 1–5 (INSTALLATION VIEW), 2004

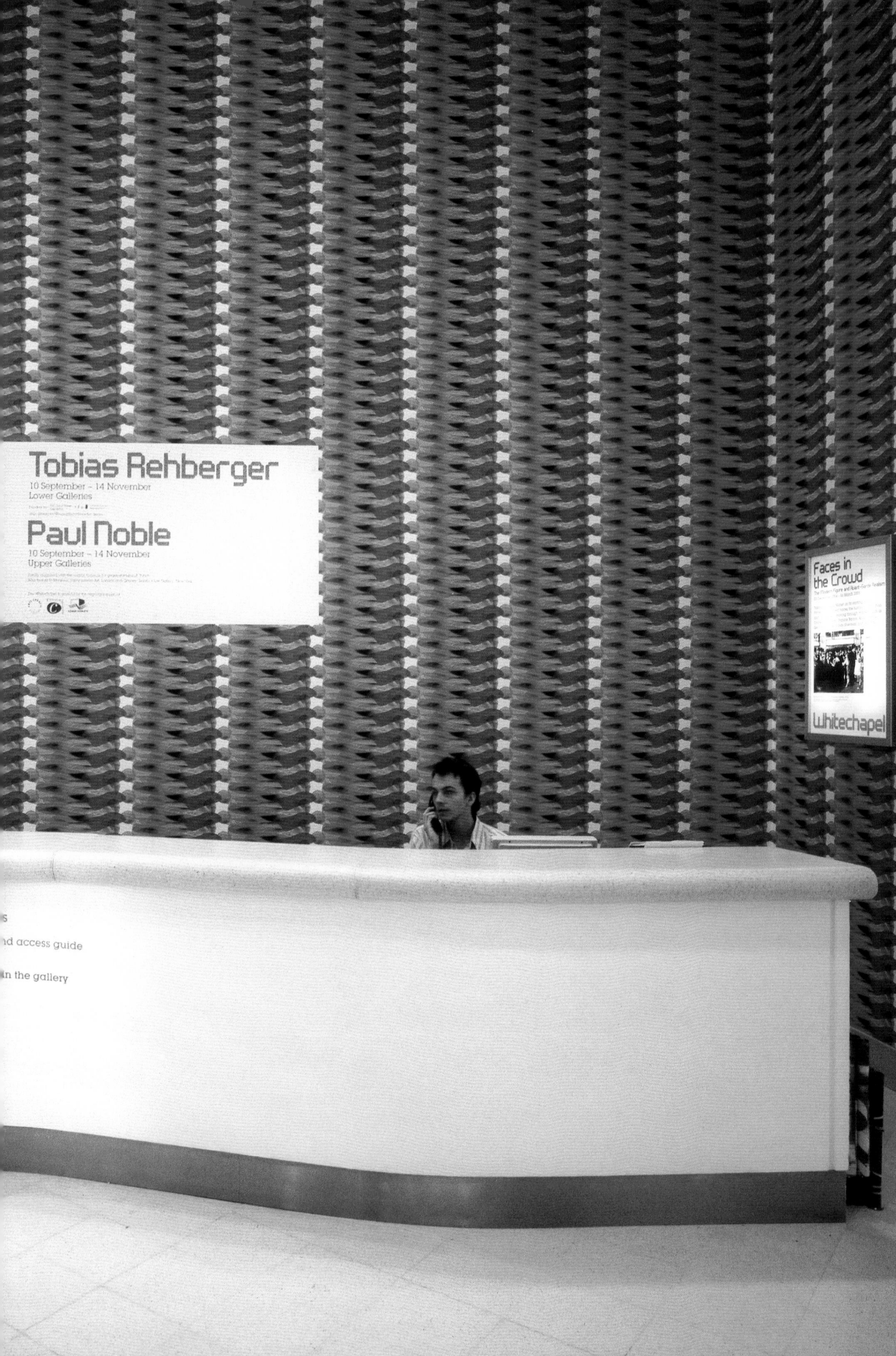

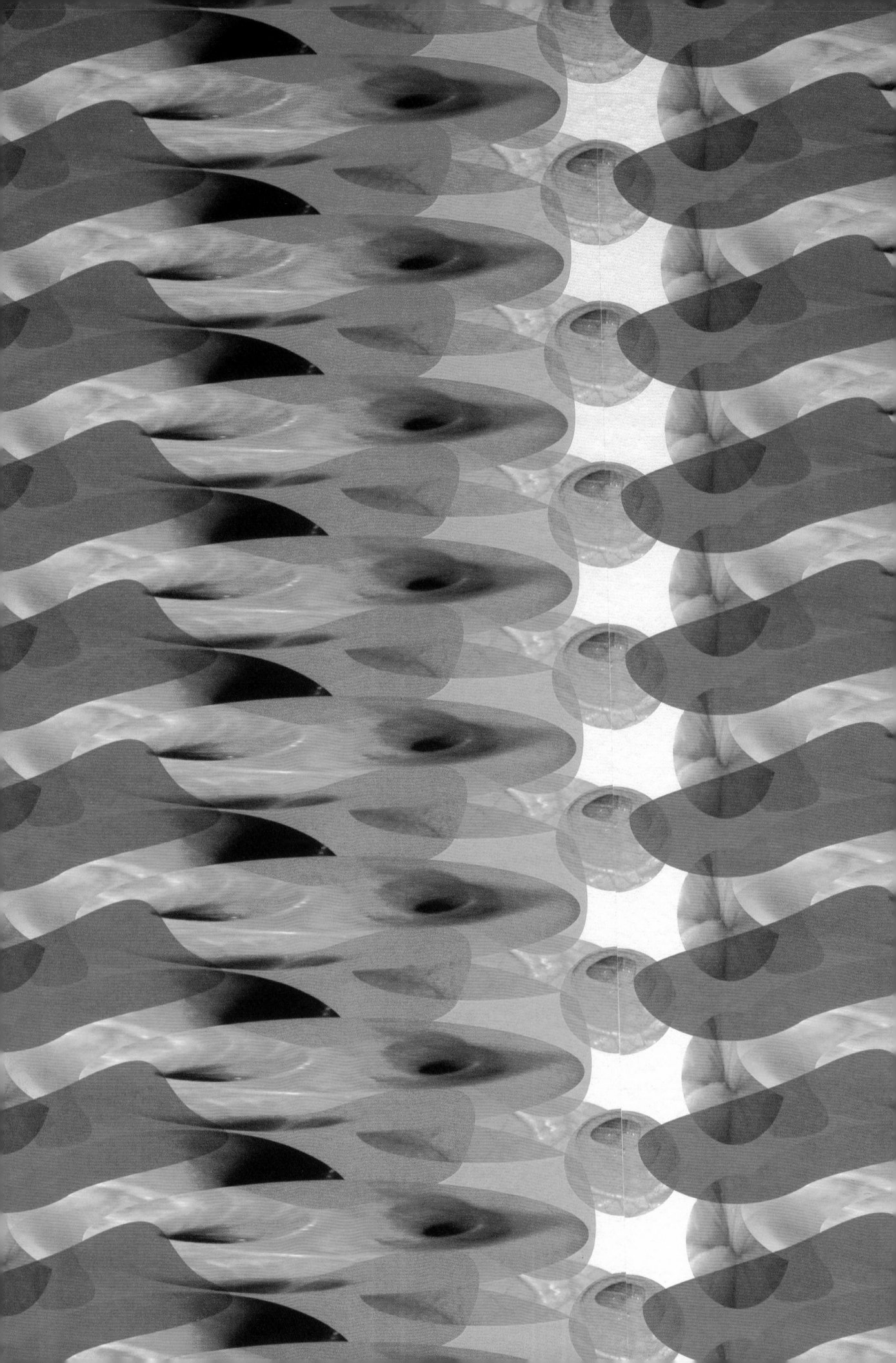

A group of vases, conceived as portraits of artists; an outdoor bar with DJ and red astroturfed roof terrace; a cinema, just for one person; a blue canopy of glass lights switched on and off by triggers in seven locations around the world. These are just some examples of the objects and environments, as diverse as they are prolific, created by the German artist Tobias Rehberger. They provide a background for a project at the Whitechapel Gallery in London presented in the autumn of 2004.

What are the common elements in this eclectic practice? Despite the fact that Rehberger works in the realm of objects and sculpture, the effect of each of his projects is to create a situation which does not erupt so much as emerge from normal conditions which are radically altered. ('I shove things into a form, rather than giving them a form.') His work shares the ambitions of a historical figure also interested in creating 'situational architecture', the American artist Gordon Matta-Clark who in the 1970s similarly proposed taking 'a normal situation and retranslating it into overlapping and multiple readings of conditions past and present'.

Rehberger's repertoire of forms draws on what the art historian Norman Bryson once defined as the slow time of material culture – man-made objects, the surfaces of which change with new technologies and fashions, but the functions of which remain fundamentally the same: a chair, a vessel, a light, a room with a view.

The artist's objects and environments do not only draw on a repertoire of daily use; they are also produced to mimic the shiny perfection of the manufactured. He turns to industrial processes to make objects that look as if they are mass-produced, part of a continuum, from the zone of everyday mass culture. However, their idiosyncrasies in terms of colour, size, function or location make us look again. These things or environ-ments do not fit in. Red astroturf? A one-seat cinema? They are works of art that propose new rules of engagement not only in their internal dynamics, but also for everything and everyone in their vicinity. Further-more, Rehberger is careful not to add anything extraneous to the world, often choosing to amplify – or like the Situationists, *détourner* – what is there already. For his London project the artist has made a series of posters. Based on ads for his favourite brands and products, he does not appropriate their logos to offer a critique of consumerism; instead he prefers simply, to *improve* them.

Like airline route maps, Rehberger's objects and environments are en-meshed in a web of connections, public and private, spatial and temporal. There is the artist himself, who is viscerally exposed in the Whitechapel foyers via images of his internal organs transformed into wallpaper. In his 1884 treatise 'Useful Work Versus Useless Toil', William Morris extols

the potential social and moral virtues of craft, architecture and domestic decoration: 'We must begin to build up the ornamental part of life – its pleasures, bodily and mental, scientific and artistic, social and individual.' Transposing a form that is essentially private, domestic and decorative into the austerity of the white cube, Rehberger also transposes his inner self, photographed in almost unbearable intimacy, into public space. The unique, singular body of the artist becomes a mass-produced commodity ready to offer the service of ornamentation. As ever, his aesthetic sensibility is superb, transforming as it does the abject nature of a series of orifices into a pattern of dazzling beauty.

Installed at the entrance to his exhibition as a form of immersion within the body of the artist, Rehberger's wallpaper is balanced at the end of the exhibition with actual walls and silhouettes of windows that exactly mirror his studio in Frankfurt. The viewer exits through the site of artistic production, a space that is usually invisible and far away, removed from the site of public experience.

Herein lies another characteristic of Rehberger's work – at the same time as physically immersing his audiences within an environment, he simultaneously propels their minds into virtual geographies that can extend around the world. Rehberger's mesmerizing installation of blue glass globes at the 2003 Venice Biennale was activated by seven triggers located variously: at the foot of a mountain in the Himalayas; in an abandoned Burger King in Kyoto; in a pumpkin field in the Walachi region in Rumania; in a toilet in Mestre; at a sink in a pub in Frankfurt; and at the 'Canale Grande' in Las Vegas.

For his Whitechapel project, the artist similarly deploys light and colour to draw the viewer into a room that hovers in space. Its interior appears and disappears according to a single light suspended in the middle, an exquisite orb of intersecting discs of transparent red, yellow and green Perspex. This source of illumination only appears when it is switched on by a trigger, located in the bedroom of Tobias Rehberger, a fifteen-year old student in Mannheim. If his exhibition at the Whitechapel hints at being a kind of portrait of the artist, this *doppelgänger* (whom Rehberger located by means of a detective), throws us off the scent.

Indeed the artist's installations are completely interdependent on the viewer. By taking on the form of utilitarian things or spaces, his works invite us to activate them. They are clearly functional in offering an illumination of a space, somewhere to sit or something to gaze at. But their presence is ambient and their proposed use invites us to pause and contemplate, rather than to labour or act. Their effect is to switch off instrumental action or thought in order to stimulate a kind of subconscious cognition: 'imagine a situation where no thinking takes place, that has instead something of a meditative nature ... so there's nothing much going on in the conscious part of the brain, other than that images are being transferred'.

Rehberger also invites us to travel through time. A child of the 1960s, his aesthetic has emerged from the postwar pop/modernist design that is

still a feature of our urban landscape and cultural heritage. The *mises en scène* that the artist presents resonate with aspects of a recent design history; but they also occupy the conceptual category of model or pavilion. In this 'what if' zone of possibility of a mini utopia (with a small 'u'), there is the implication of a future.

Rehberger's work may cause us to go back in time, to remember. It also persuades us to dream. But it is the invocation of the here and now that is overwhelming. Rehberger's works make an optical impact through his use of a vivid spectrum of colours both translucent and opaque. He creates buoyant volumes embodied by forms that temper a strict functional geometry with a soft, organic structure. He delights the touch with the texture of hard wood, glossy plastic or soft yielding fabrics. Deploying an aesthetic register of supreme sensuality, even aura – the use of light is a persistent feature – Rehberger's practice is enthralling in its sheer perceptual power and profound actuality.

Yet, his use of scale and form resists the dynamics of the sublime. His are not monolithic, dominating structures. Rather they are constantly set in flux by contingency of context, by the chance elements of a situation and, crucially, by the shifting sensibilities of the individual subject. 'The truth based on the way the day goes.'

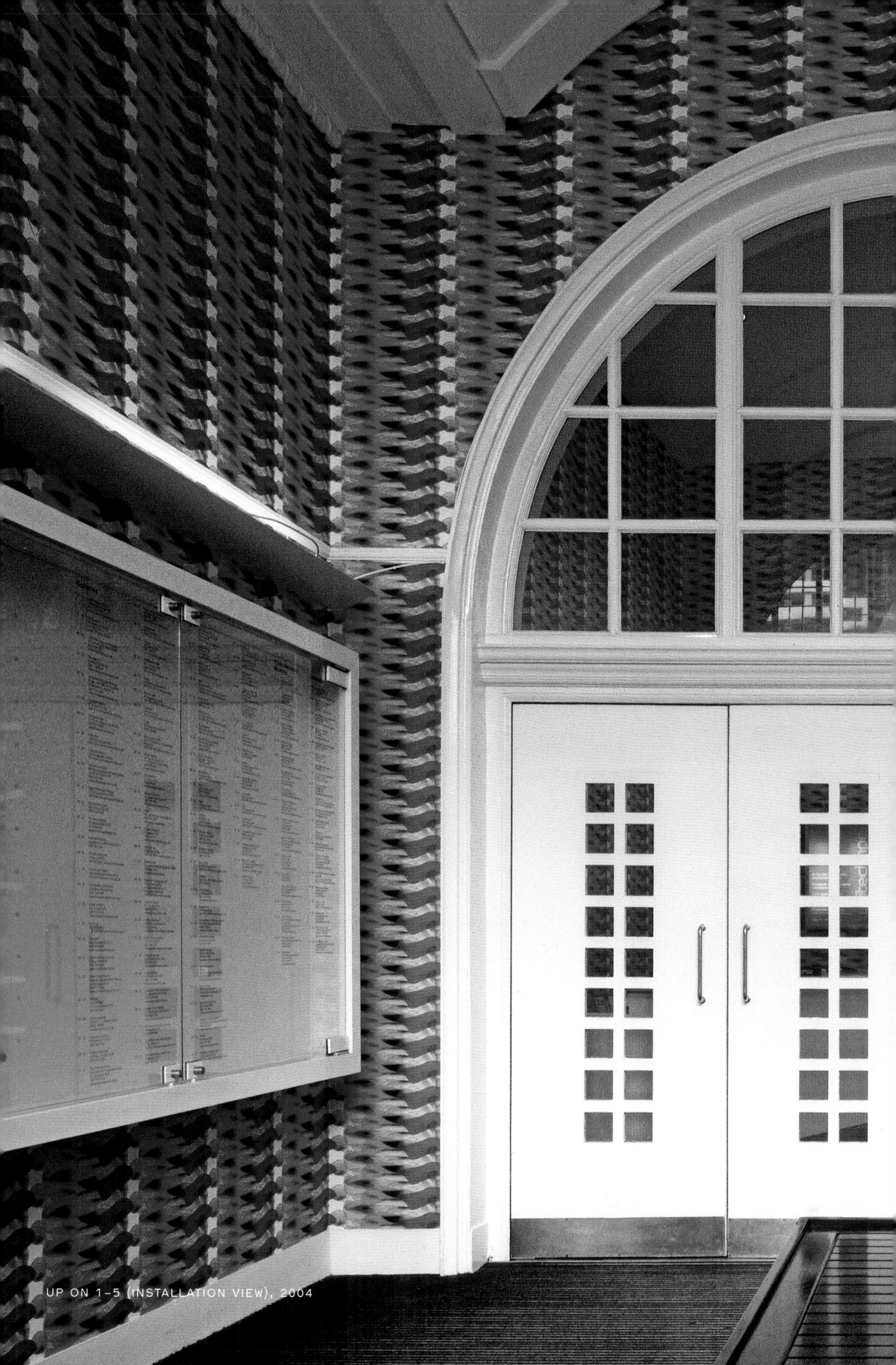

UP ON 1-5 (INSTALLATION VIEW), 2004

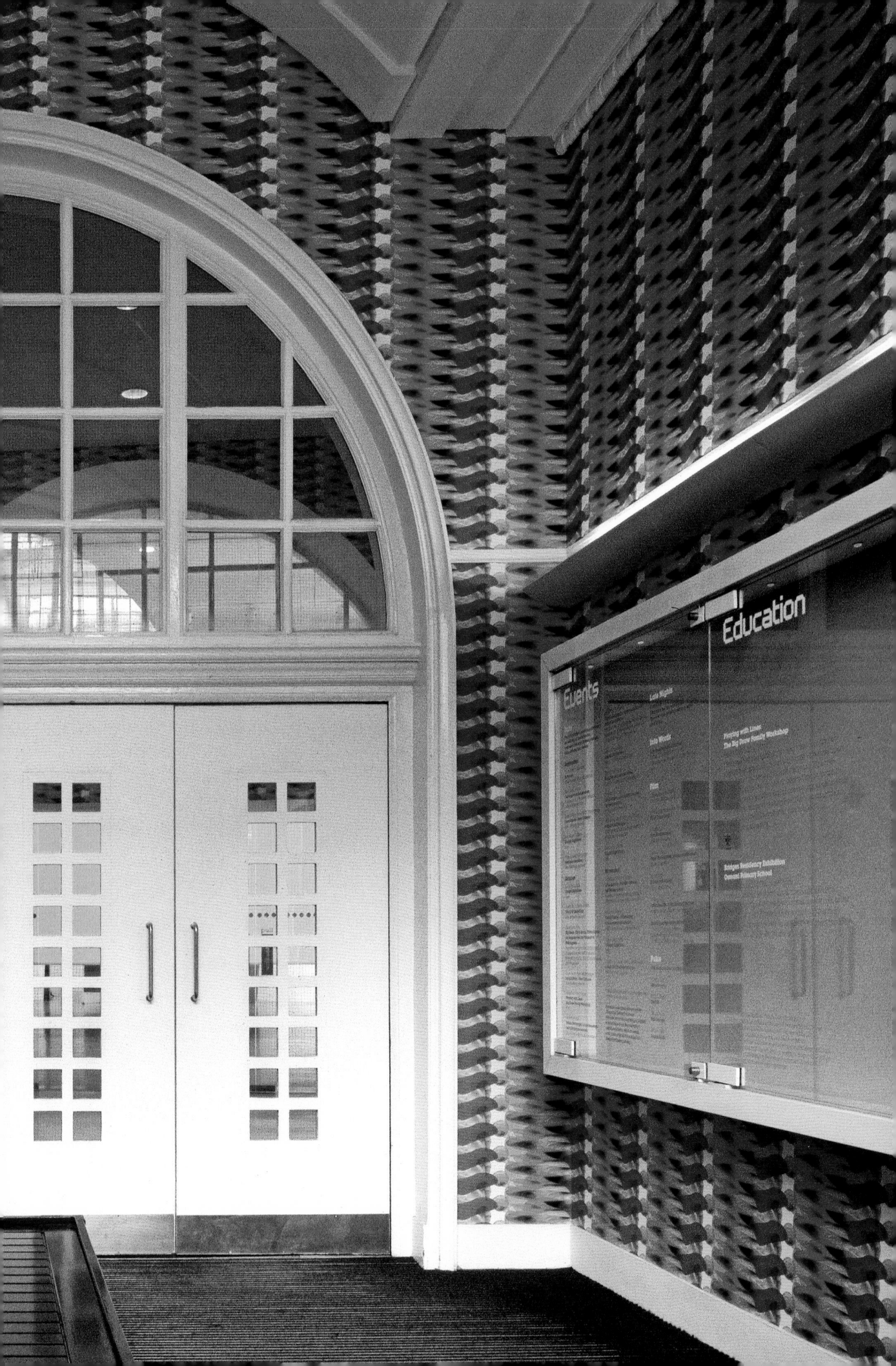

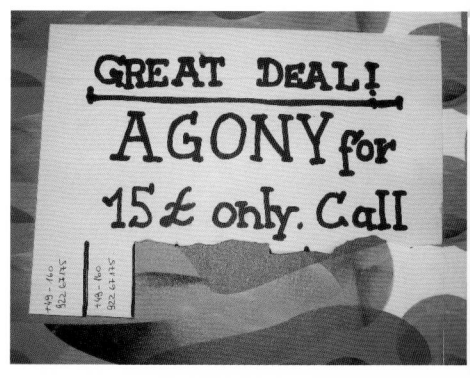

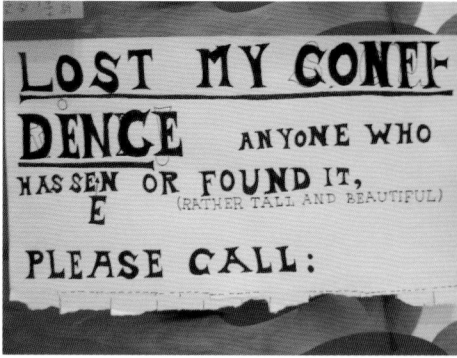

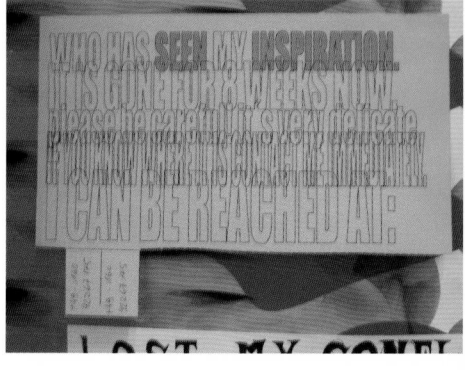

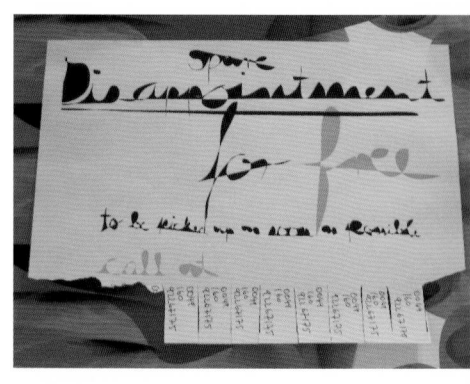

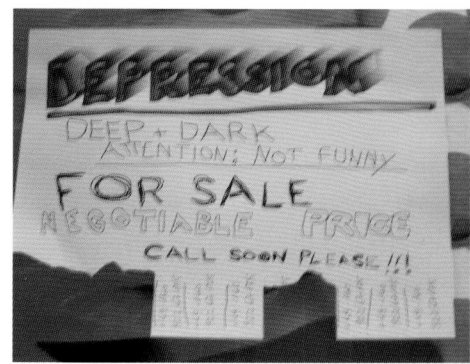

UP ON 1-5 (DETAIL), 2004

A discussion between Tobias Rehberger & Anthony Spira
with a postscript by Rirkrit Tiravanija

ANTHONY SPIRA Some years ago, you were involved in a project in Thailand with Rirkrit Tiravanija. Could you describe it?

TOBIAS REHBERGER Rirkrit and Kamin Lertchaiprasert bought a plot of land right in the middle of the rice fields outside Chiang Mai. The idea was to invite artists to build small-scale houses to use for holidays or for the students of a kind of art/experimental/agricultural school. For an exhibition about art and architecture at the Moderna Museet in Stockholm, Rirkrit and I had basically the same idea: we proposed building a wooden hut that was to be transported to Thailand afterwards. I wanted it to be entirely built with Scandinavian materials (like Finnish plywood and Swedish screws, etc.) unsuitable for local climatic conditions. The idea was that it would start rotting slowly, so that it would gradually be rebuilt using local materials. It has now been there for three years and every year it needs restoration. Approximately 70% of it is now made with local materials.

There are also a couple of more communal houses, like a bathhouse and a kitchen. Our very first project was aimed at building a kitchen/cafeteria. At this time, we were involved in a project in Portugal about art and food. Superflex, Rirkrit and I tried to design something that could later be moved to Thailand. The plan was to erect a classic Thai storage house and transform it into a kitchen/cafeteria. Superflex were working with these bio-gas systems and Rirkrit was busy with the kitchen stuff. I was in-between and thought of using the floor between the one where people eat and the ground floor. I proposed a weirdly shaped, coloured floor with a cushion; the bio-gas system pumps automatically into this cushion, and when people come to eat, the pressure on the cushion releases gas into the kitchen. It's only when people come to eat on the first floor that pressure releases the gas into the kitchen. The more people come to eat, the more gas there is for cooking.

ANTHONY SPIRA This project is emblematic of one aspect of your work, but even more of Rirkrit's, in the sense that it depends on visitor participation.

TOBIAS REHBERGER Rirkrit's work is more about participation and community than mine. I'm more interested in the disruptive and uncontrollable aspects of participation and the different perspectives that are offered by working with others.

ANTHONY SPIRA For your exhibition at Portikus in 1996, you handed out questionnaires during the previous show, asking visitors what improvements they would like to be made to the building.

TOBIAS REHBERGER I handed out these questionnaires without telling people that it was for a show. It was about Portikus trying to improve its functional

qualities and people were able to give their recommendations. In the end I took about 15 points and tried to realise them in a way that would fulfil the requests, but also go against the function of the gallery as an art space. For example, somebody complained about the floor, saying it should be wooden, that it's much nicer to walk on and that it makes a nicer noise than the PVC flooring they had at that time. So I made this wooden floor but painted it a yellowish green – so that anything in the gallery would become greenish from the reflection. Of course, this went against the sensible, neutral art space where you present painting, for example.

ANTHONY SPIRA Another instance might be the signage you used for the bookshop.

TOBIAS REHBERGER There were no existing signs for the bookshop or the toilet, so somebody recommended we do that. But then my bookshop sign became such a big sculptural element in the space that it would have disturbed any other sculptural manifestation.

ANTHONY SPIRA The bookshop sign was so big that the letter 'O' doubled up as the door to the bookshop. It created a step that people had to climb over.

TOBIAS REHBERGER Exactly. On one hand, the project was fulfilling people's recommendations, and on the other it was resisting or going against them.

ANTHONY SPIRA Other examples that show your interest in collaborating with people are the incomplete designs that you sent to a car factory in the Far East or to furniture workshops in Africa. Because the designs were incomplete, the manufacturers became implicated in the creative process. Your interest in blurring the role of the artist reminds me of works by Martin Kippenberger who actually taught you, and of Franz West, both of whom have worked closely with friends, other artists or their assistants so that the artist could not be defined as a single person. Another figure could be Alighiero Boetti who worked with Afghan kilim makers. Have these artists been important for you?

TOBIAS REHBERGER They might be inspirational in how their work questions the role of the artist, the role of the viewer and the role of art in general. Less obviously perhaps, Donald Judd's work was equally inspirational. His work brought up questions about authorship and the practicalities invol-ved in the making of things. An interesting idea or goal could be to find a way to make works like Judd's, without being ideological or without having to establish a steady set of parameters. How could you achieve quality for something that, on the one hand, does something similar to his 'objects' and, on the other, is shifting perception all the time? Perhaps there is a way of working towards finding the core of what art is; perhaps it is possible to do this in a different way to Judd. Instead of looking for the core of art through a reductive process, perhaps it could be through an additive one … I would like to achieve something like this, without having to be limited in any way and without having a rigid set of parameters for what constitutes quality. It doesn't work like this for me, it's always a matter of perspective. I recognise the existence of a quality in the thing itself, but I don't agree that you can only look at things in one way.

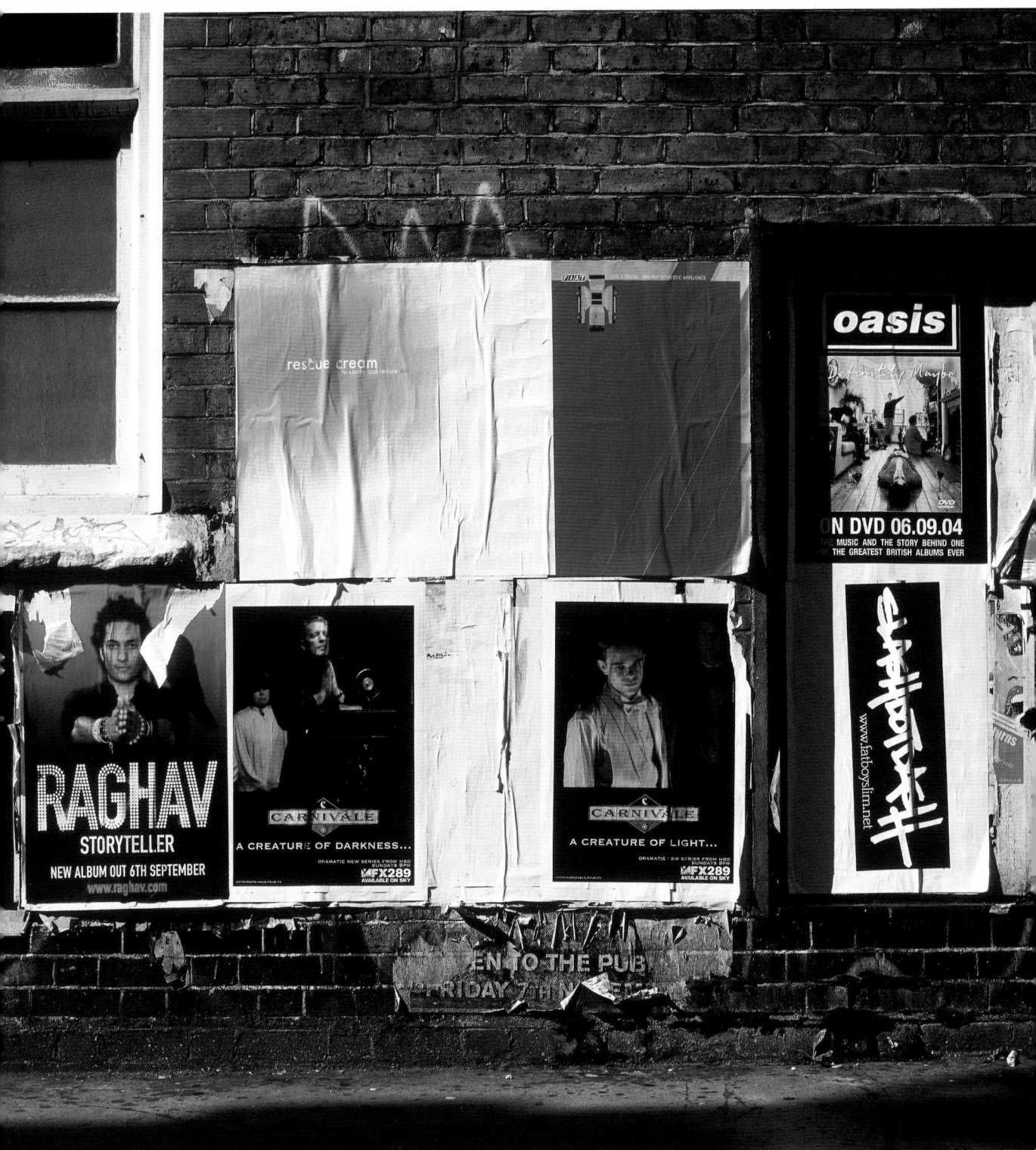

ADS 2, BACH RESCUE CREAM + FIAT PANDA

ANTHONY SPIRA There is an obvious familiarity with all of these strategies in your work, the difference lying maybe in the seductive sheen that your work possesses. Kippenberger and West are 'punkish' and 'outsiderish', while Judd is rigorous and rigid. These features exclude all these artists from being immediately seductive – perhaps they are an acquired taste? It seems you're not afraid of creating an immediate sensual rush.

TOBIAS REHBERGER I'm probably not afraid of it because I don't see a problem if somebody likes or dislikes something for its aesthetic qualities – as long as there are other qualities too. Of course, seduction can be a trap, but I like the idea that you don't have to go into any depth to enjoy something, although if you do, then there's more to gain. You can appreciate it on different levels. Maybe it's like a trick to keep people awake, to see if their interest goes beyond the surface of things, while still allowing them not to feel the need to go deeper. If something is very rough or unpleasant it's very hard not to say 'OK, that can't be it! There must be some other qualities in it.' I like the idea that you don't have to do that. It's also a matter of not being didactic.

ANTHONY SPIRA Have you recognised an evolution in your work over the last few years? The show *Night Shift*, at the Palais de Tokyo, seemed less collaborative or directly engaged with visitors, for instance. The whole exhibition created quite a tight philosophical rumination or an epic poem perhaps, ostensibly about light and dark but also, as an extension, mortality.

TOBIAS REHBERGER Maybe I'm getting old! For that exhibition I decided to bring together some works that dealt with light, and chose to open the show only once the sun was set, which I guess is quite poetic in itself. This came out of practical considerations. For example, we couldn't close the skylights as it would have been too expensive. Other parameters were set by factors out of our control, such as when the sun set or rose, although this could be anticipated. The combination of these practical matters led me to this idea.

ANTHONY SPIRA The posters that you have designed for the Whitechapel exhibition will be fly-posted around London. You did a similar project in Frankfurt before. Can you say a few words about it?

TOBIAS REHBERGER It's quite a simple project. The posters advertise products that I really like and that I think should be advertised. Fly-posting is usually done for clubs, parties or political reasons and I was wondering how 'I like Coca-Cola' or 'I like Birkenstock' could be political statements. Public posters or announcements are not really very individual. It is unusual to advertise a product with an individual recommendation. I thought it might become a political statement in a way and that illegal fly-posting would be the right way to advertise products that an individual likes …

ANTHONY SPIRA You have talked about the posters as 'improvements' on the designs of the products in the ads, which is quite unusual because artists tend to 'subvertise' or be more overtly critical of branding.

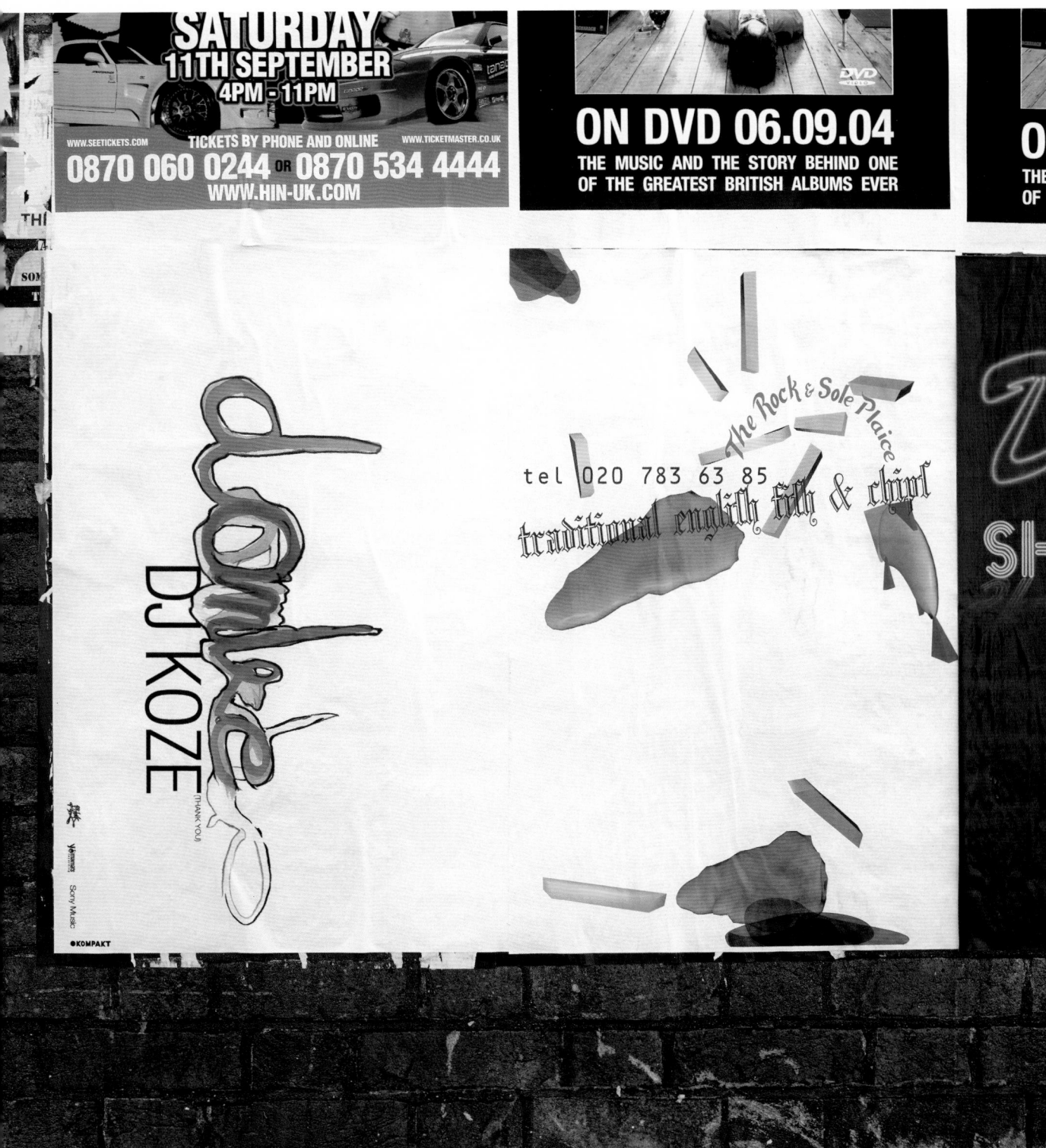

ADS 2, DJ KOZE + THE ROCK AND SOLE PLAICE

TOBIAS REHBERGER Why can't being positive also be a critical element? There's a dimension of politics that allows one to be as positive about things as one can be critical. It induces a type of problematic that makes it even more critical – not of the product, but of the general idea of how we, especially in the art world, deal with statements and criticism.

To be naïvely honest, most of the products I chose have shitty advertising. If you really want to say that you think something is a good product, and that people should participate in the quality of the product, you have to try to improve the advertising campaign too.

ANTHONY SPIRA It thus appears that you're complicit with promoting consumerism. The products you've chosen are the 'finest Swiss underwear', a moisturiser, etc. Is there an element of parody in it as well?

TOBIAS REHBERGER It's honest, naïve and ironic at the same time.

ANTHONY SPIRA This double-edged aspect of your work is very important, whether it's fulfilling people's requests while simultaneously resisting the 'improvements', or promoting and also criticising advertising design. In addition, the wallpaper you've produced uses images taken with an endoscopic camera from every orifice in your body and it's unexpectedly beautiful.

TOBIAS REHBERGER In a general sense, I'm maybe a bit sceptical about what one believes in. Things can be practical (or beautiful) in one way, and from a different perspective become totally different. I'm very interested in the possibility that something is not only what it is, but also has a bad side. Every positive quality implies its problematic side. It depends a lot on what perspective you have on things or how you look at them, how you go into them.

For the wallpaper, I wanted to literally and naïvely deal with the idea that things come from the 'inside of the artist'. By making it into wallpaper, it acquires a metaphorical quality, alluding to the possibility of visitors being 'inside' the body of an artist.

I also brought some A4 leaflets, like the ones pinned onto announcement boards at supermarkets in Germany where you sell a sofa for £20 or something like that, and your telephone number can be torn off. I made these announcements that say 'Lost inspiration. If anyone sees it, please call bla, bla bla', or 'Selling depression', and so on. It had to do with using the entrance or information area of the gallery. It also has to do with where the artist works from and what the conditions are in which an artist can or cannot develop a strong work. Things that have to do with an artist's inner problems.

ANTHONY SPIRA The series of prostheses you've made develops a more externalised physical presence of the artist.

TOBIAS REHBERGER The initial idea was to redesign parts of my body. They were going to be like substitutes, to provide a different idea of what you are.

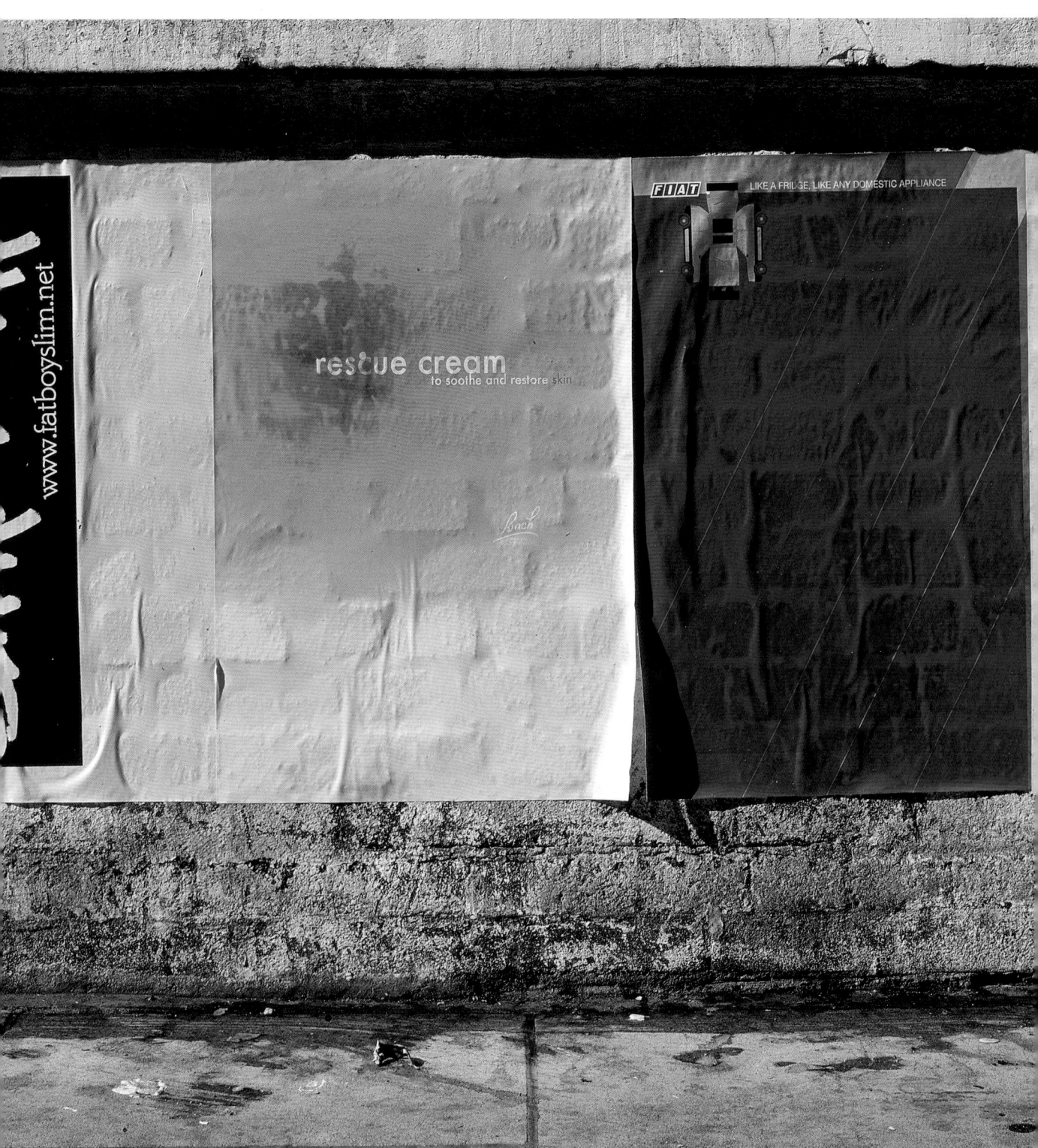

ADS 2, BACH RESCUE CREAM + FIAT PANDA

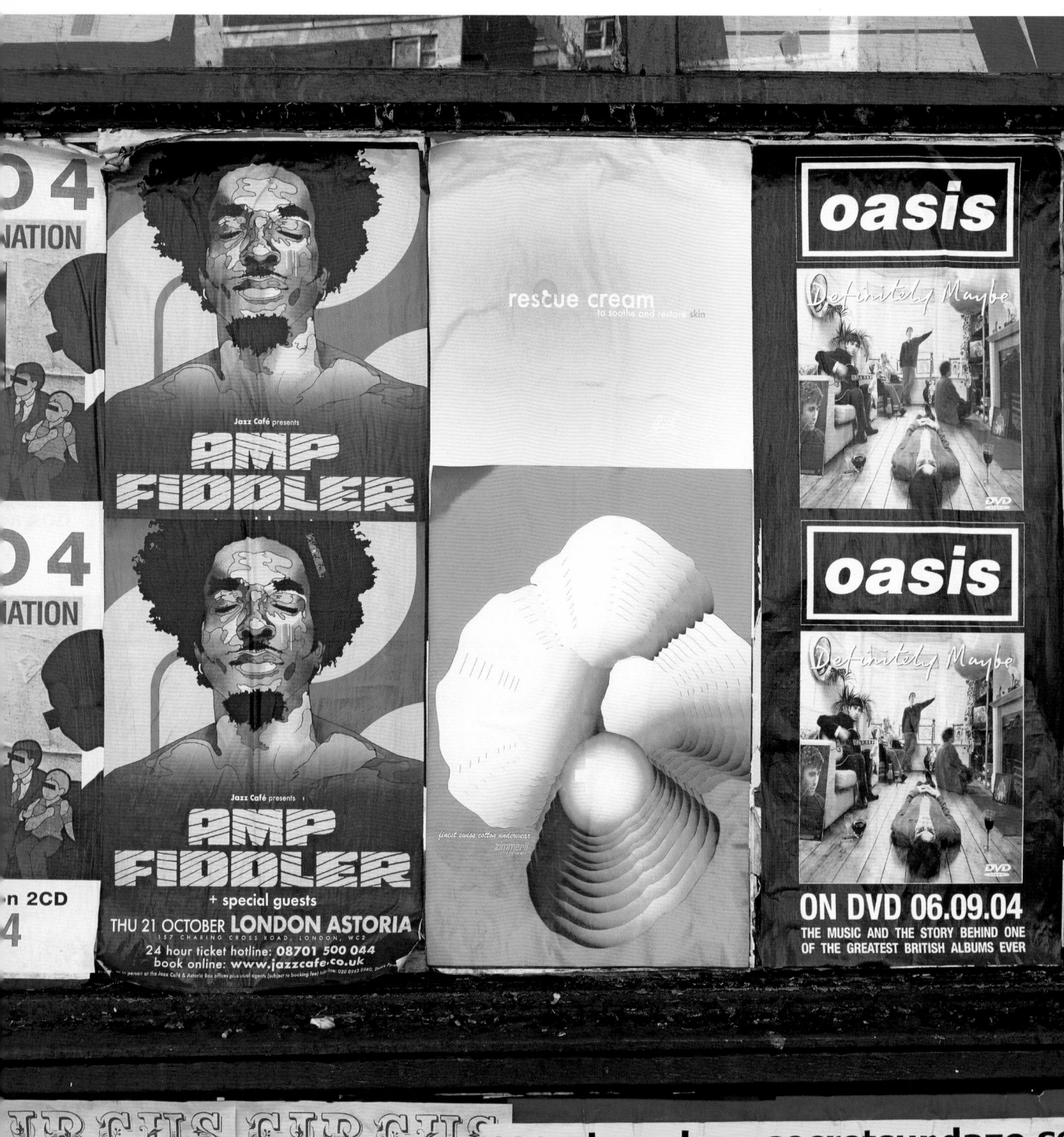

ADS 2, BACH RESCUE CREAM + ZIMMERLI

All the works in this show are related to self-portraiture. The works deal with me as a person, as an individual, and the prostheses are made to fit my body, so that if I lose my right arm, the prosthesis for the right arm would fit my body perfectly.

I was wondering why prostheses always try to mimic what the body already has. They are never going to be as good, but try to get as close as possible. I was also thinking again about this ridiculous 'improvement' idea. For example, one of the prostheses for the arm has a hole that probably holds a glass better than a hand could. I also thought that if I had to substitute a part of my body with a plastic part, why shouldn't I make it look better or function differently?

ANTHONY SPIRA At one point you called the hovering chamber in the centre of the gallery a 'caramel bonbon'. It's changed in colour and hue since then ...

TOBIAS REHBERGER Now it's a juicy fruit instead. I wanted to make a very simple, big form that takes up almost all the space in the gallery, so that when you come in, you only see this big block — almost like an abstract, minimalist sculpture — but which would also have an 'inside'. This work is playing around with the ideas we evoked when we were talking about finding the core of art in Minimalism's strategy. You can enter the space and the inside will either be completely black — so that you don't see anything — or you will see a lamp when it's switched on. The core of the work appears to be a kind of shiny, reflective, translucent object. I thought it should be activated by someone who has nothing to do with the exhibition. So the experience of the work is not in the hands of the curator or the artist. Finally I decided to find someone else, also named Tobias Rehberger, who could be in control and who could influence the system. The light is only switched on if the other Tobias Rehberger turns the light on in his own room.

ANTHONY SPIRA The decision to use another Tobias Rehberger also seems to throw visitors off the scent, because, with the exception of the bodily wallpaper that engulfs you, all the works in the show function peripherally around you. They function like clues or hints. It's almost like a 'treasure hunt' to find the artist. People are always searching for the artist in the art — a bit like looking for meaning in art — even if artists have forever hidden themselves in their work disguised as codes for example. It's like believing that a brushstroke provides a hotline to the artist's psyche. In this show visitors are piecing a puzzle together in their minds, almost like a *cadavre exquis*. With the lamp piece, people might think that they are tracking you down, finding the core of the art, that here is an indication of your activities. By replacing yourself by another Tobias Rehberger, this turns out to be an illusion or a case of mistaken identity.

TOBIAS REHBERGER Yes, it's someone completely different but it's not a lie. He is Tobias Rehberger. What do people want to see? Do they want to see Tobias Rehberger? Do they want to see artwork? What do you want to see when you go to an art show? Do you want to find yourself? Do you want to find the artist? Do you want to find yourself in the artist? Do

ADS 2, BACH RESCUE CREAM

you want to find yourself in the work? Are you hoping to find something else? These are all questions that are involved in the piece.

ANTHONY SPIRA And also in the Plexiglas structures that replicate the proportion of your studio?

TOBIAS REHBERGER All the works show a different angle of this cluster of topics. A portrait gives you hints as to the 'inside' of a person. Perhaps the works in the show ask how much appearance reveals a personality. Or how much external features reflect an inner core.

The studio doors and windows you're referring to are the most literal, conventional and purposefully classical works from this perspective. They follow the tradition of Dutch 17th century painting or portraits where windows or doors in the background open up onto the world and provide a perspective. It's a bit like the artist inside the studio looking out of the window or, alternatively, people looking in from the outside in. Doors and windows usually focus and frame what can be seen through them. I designed these ones to be like an idea of a blurred window or a blurred frame. Like a blurred focus … like a telescope with a blurred lens. They are all the actual size of my studio and they are made so that they could replace the existing windows and doors.

ANTHONY SPIRA In effect, they are similar to the prostheses. Both series of works are properly functional in the event of a disaster. This results in quite an interesting comparison between the body and architecture. As you said earlier, entering the wallpapered room is like entering your body.

TOBIAS REHBERGER When you put a show together, you always realise that there's more in it than you consciously thought of in advance. You make connections and to some extent these things can only happen once it's all set up.

ANTHONY SPIRA Extending the metaphor (perhaps too much), in this context, with the endoscopic wallpaper and prostheses, the cabin makes me think of the right hand panel of Bosch's *Garden of Earthly Delights*, where there is a strange body that people can climb into on a chicken ladder. Can the cabin be considered like this?

TOBIAS REHBERGER Yes, maybe like a Minimal version of a Bosch painting.

ANTHONY SPIRA What about the title of the exhibition, *Private Matters*?

TOBIAS REHBERGER I don't know if it really works in English but 'private matters' to me means dealing with private or personal things, and also that the private sphere does matter, that the 'personal' is important.

ANTHONY SPIRA The intensity of the colours in the wallpaper, the brightness of the cabin, the use of coloured Plexiglas for the windows and doors, all point towards the psychological impact of vivid colours. Is there something reassuring or comforting for you about vivid colours, rather than something exciting or awakening?

TOBIAS REHBERGER Something involving, something sensual. The intensity of colours gives me the impression that they want to reach out to me, so I want to touch them back. The effect of the cabin on the whole space is maybe like a fog or like when you're immersed in water or something like this. It really has a physical effect that requires physical involvement.

ANTHONY SPIRA Is this being immersed in colour or an atmosphere something you have in common with Olafur Eliasson?

TOBIAS REHBERGER Yes. I don't know if there are the same ideas or feelings behind it, but it is definitely the same kind of sensation. When he made the round space with the moving colours (*360° Room for all Colours*, 2002), it was literally like standing in a pot of colour. There are definitely similarities. My work is not just about the physical involvement of the viewer, but that's always a part of it.

ANTHONY SPIRA The show is very spectacular, and that may influence people to understand it like a stage set in which they are the protagonists. How do you feel about the immediate aesthetic impact, the physical impact of the show? Michael Fried famously criticised Minimalism for its theatrical elements, its dependency on audiences. You often create ambient areas for people to enjoy.

TOBIAS REHBERGER This has to do with an idea I've had since I was a child. One of my dreams was always to sleep on a Van Gogh painting. Even with something as 'unphysical' as a painting, something untouchable that represents its own world, I always felt the necessity to have some physical involvement, and that this was a part of understanding things. I would have liked to sleep on a Van Gogh painting because as a thirteen-year-old child I thought it would give me more if I could touch it or sleep on it like a pillow.

Dear Tobie,

It's Sunday, and I've asked everyone to take a day off. The (retrospective) exhibition here is going on brilliantly.

How is it in London? I have been thinking about your description of the exhibition, and how much it is about you. How you are using your own body as the source of the exhibition. Since our days in Hamburg (ten years ago!), you have always used the bodies, or the limitations, or the extensions of an/others (and by bodies I don't just mean physical, but also mental), as a material to sculpt from. That is not to say chipping away at a piece of stone or wood, or making a mould or melding a molten liquid of iron or bronze, but in the sense of representation, which is sculpted without the necessity of filling or losing, a representation of the senses, a representation of existence. Not fully comprehensible in its totality upon viewing, but sensed through passage, or by passing through, as in a long journey, where at the end of the lane there is a great joint where we'll enjoy a good meal together.

So you have now come around to yourself. The other Tobie who will turn on the light ... The prostheses ...

I'm just remembering the poccetta sandwich we had in Tuscany, and recently I had another in Rome (brilliant) and then I'm reminded of the dish you always talked about, the pig (or is it the cow?) stuffed with other little animals and roasted. Which brings me to your boneless chicken stuffed with three kinds of sausage, prosthetics and boneless chicken and hollowed-out pigs with a light turned on by the only other Tobias Rehburger. It must be lunchtime. It seems our conversations always end with a good meal ... What have you been eating lately, Tobias?

Rirkrit

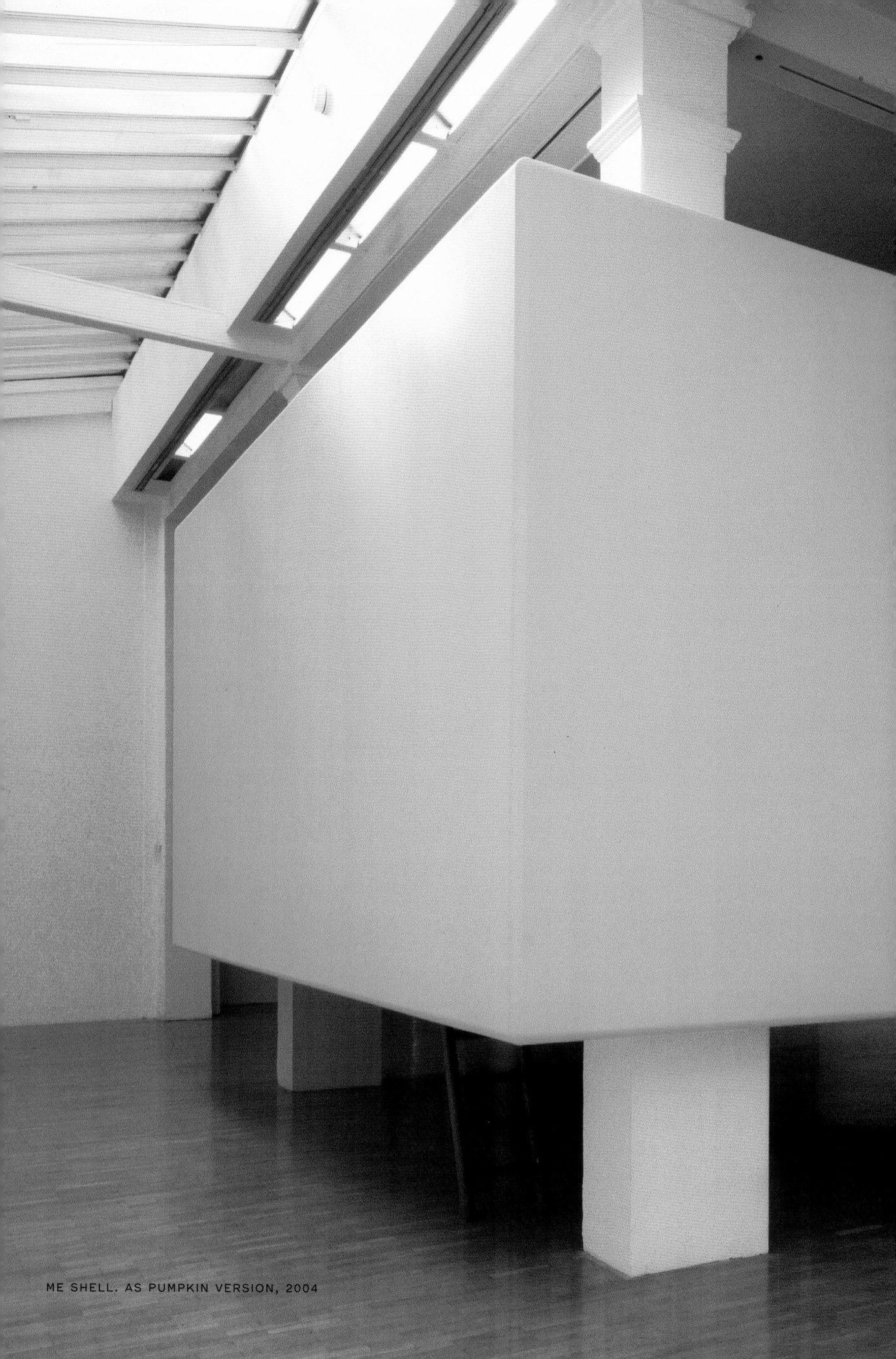

ME SHELL. AS PUMPKIN VERSION, 2004

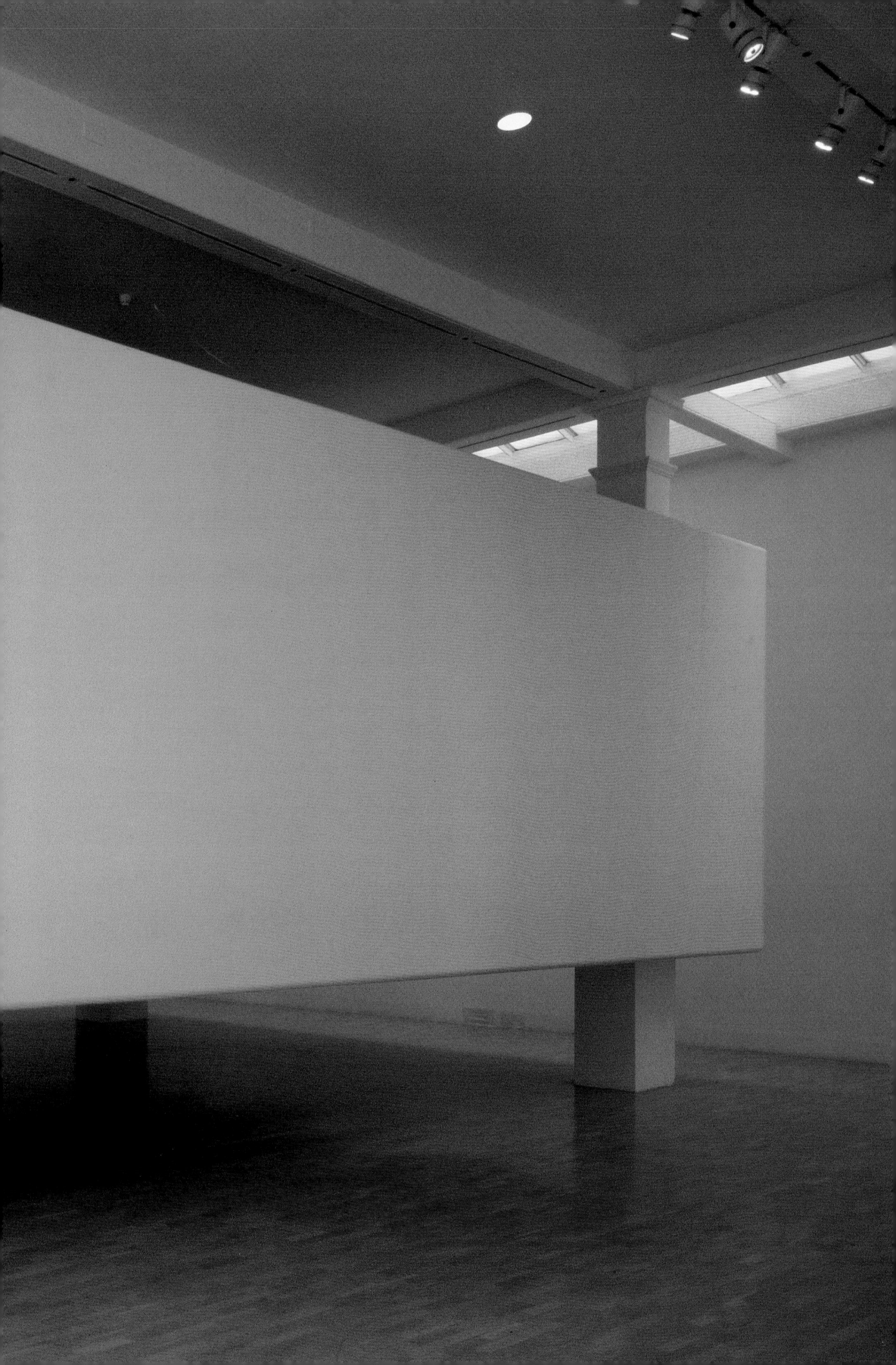

ME SHELL. AS PUMPKIN VERSION (DETAIL), 2004

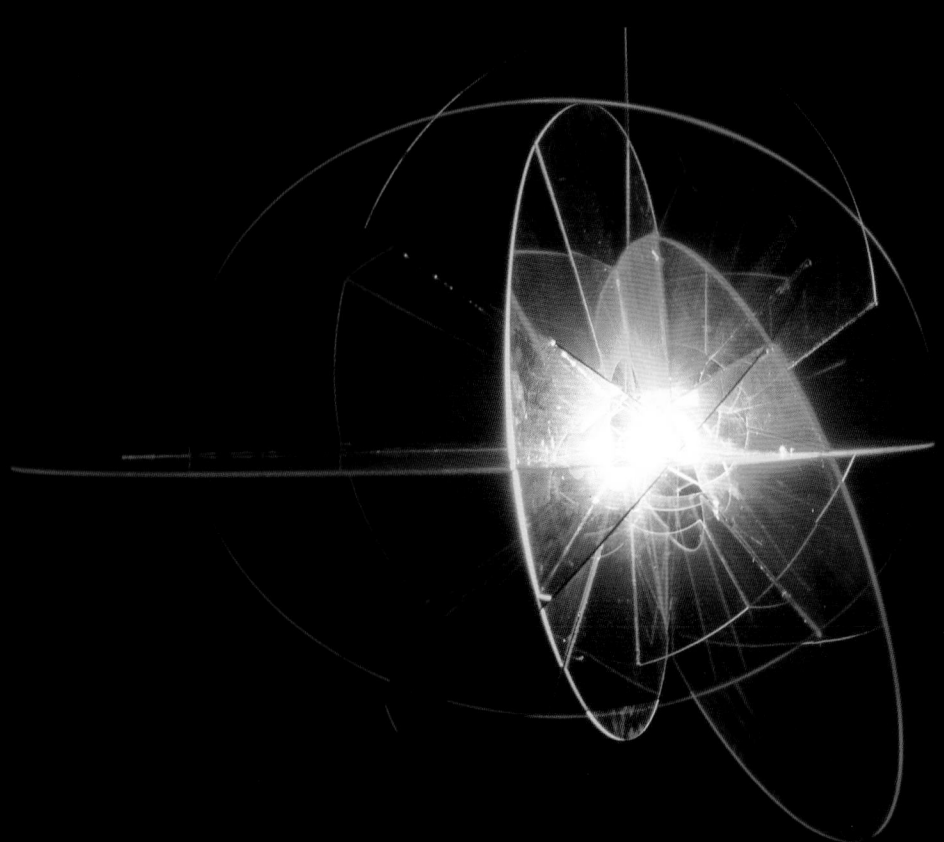

ME SHELL. AS PUMPKIN VERSION (DETAIL), 2004

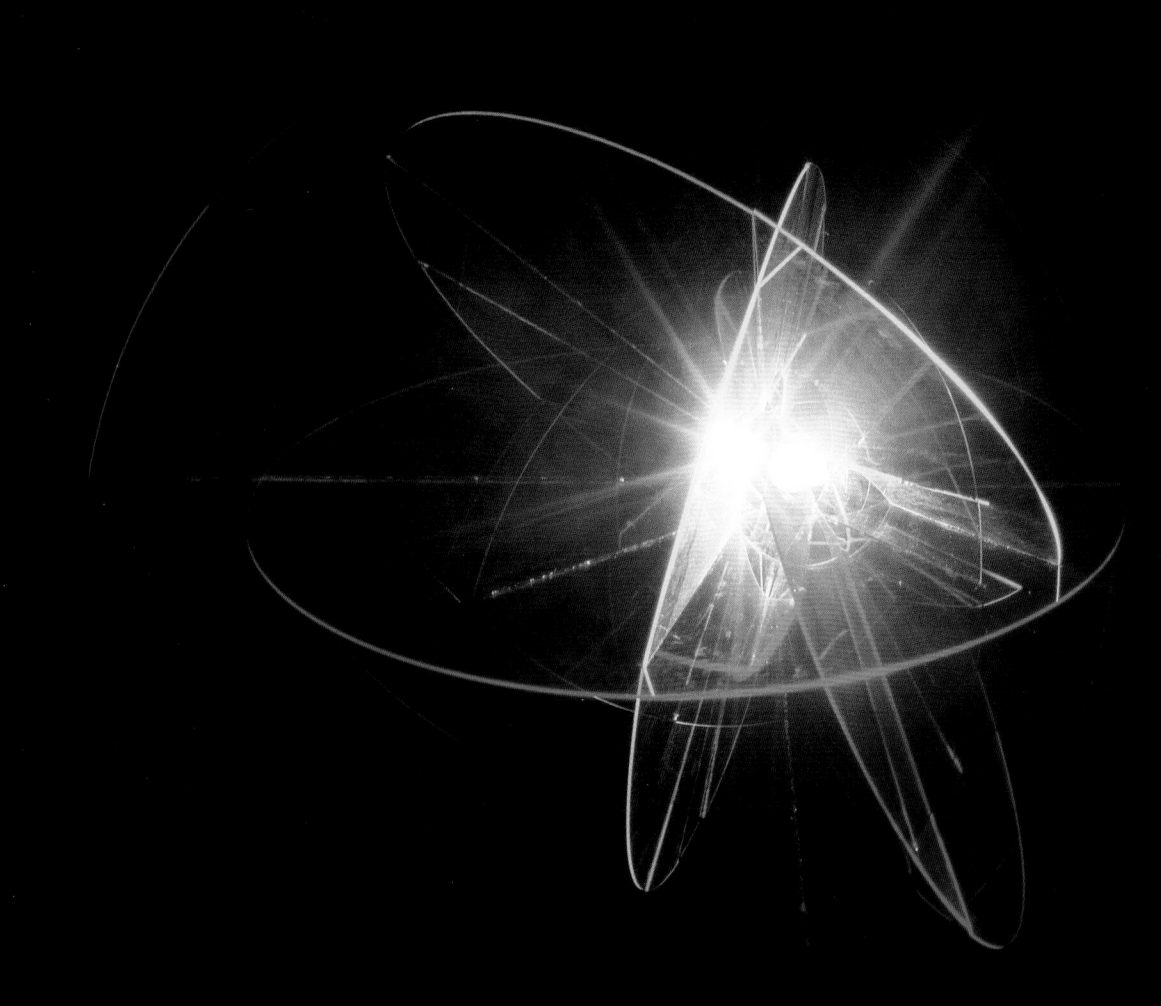

ME SHELL. AS PUMPKIN VERSION (DETAIL), 2004

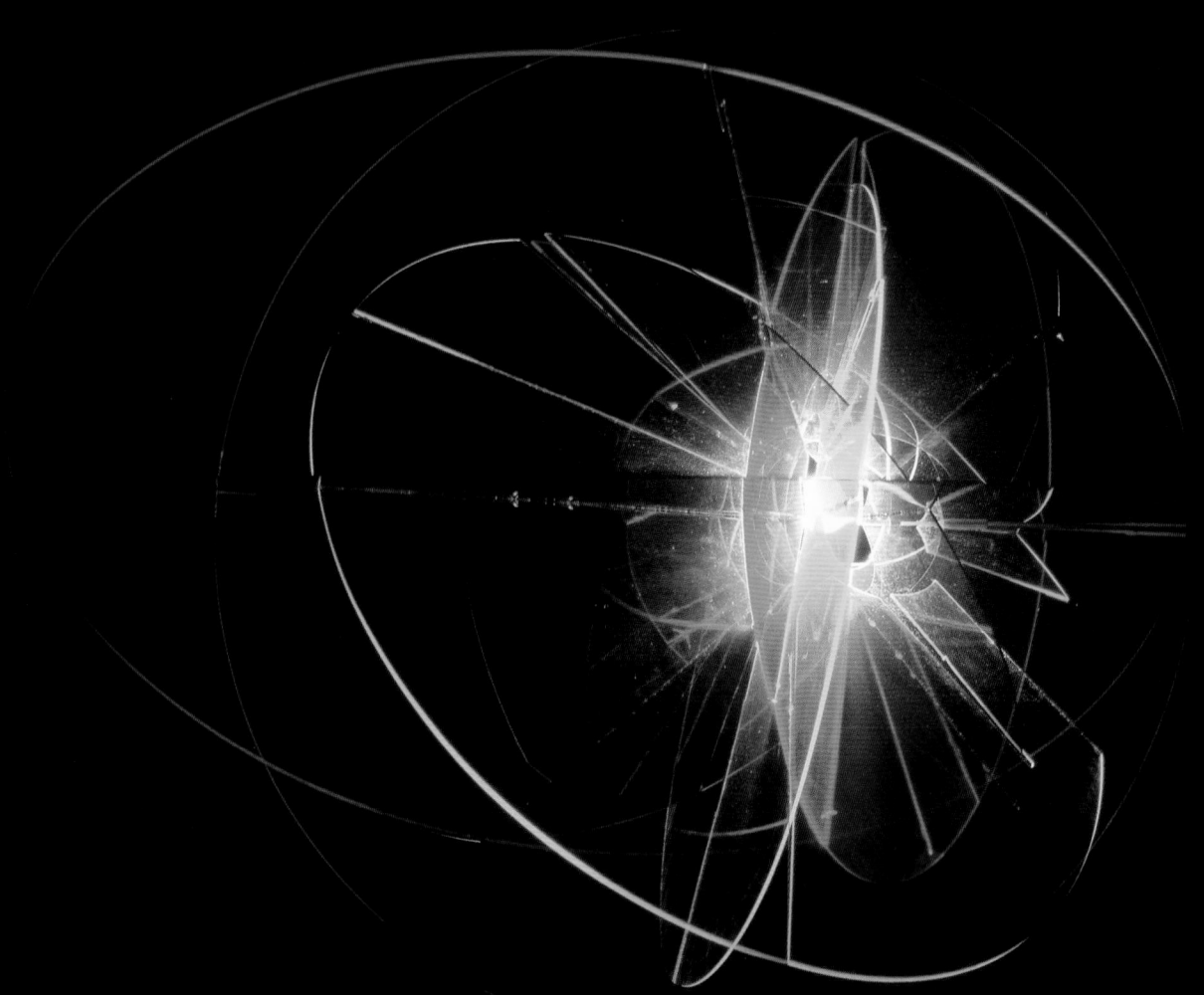

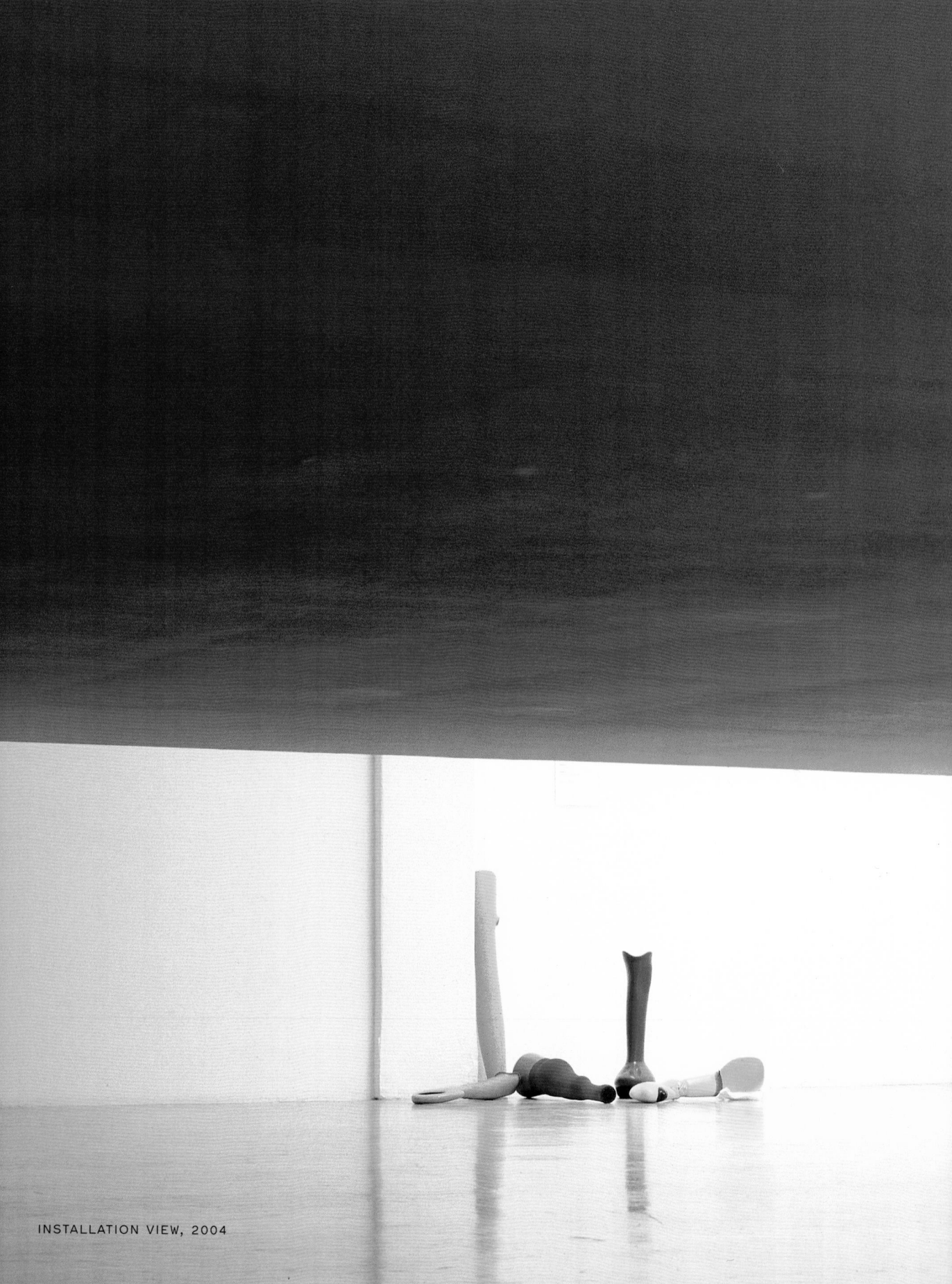

INSTALLATION VIEW, 2004

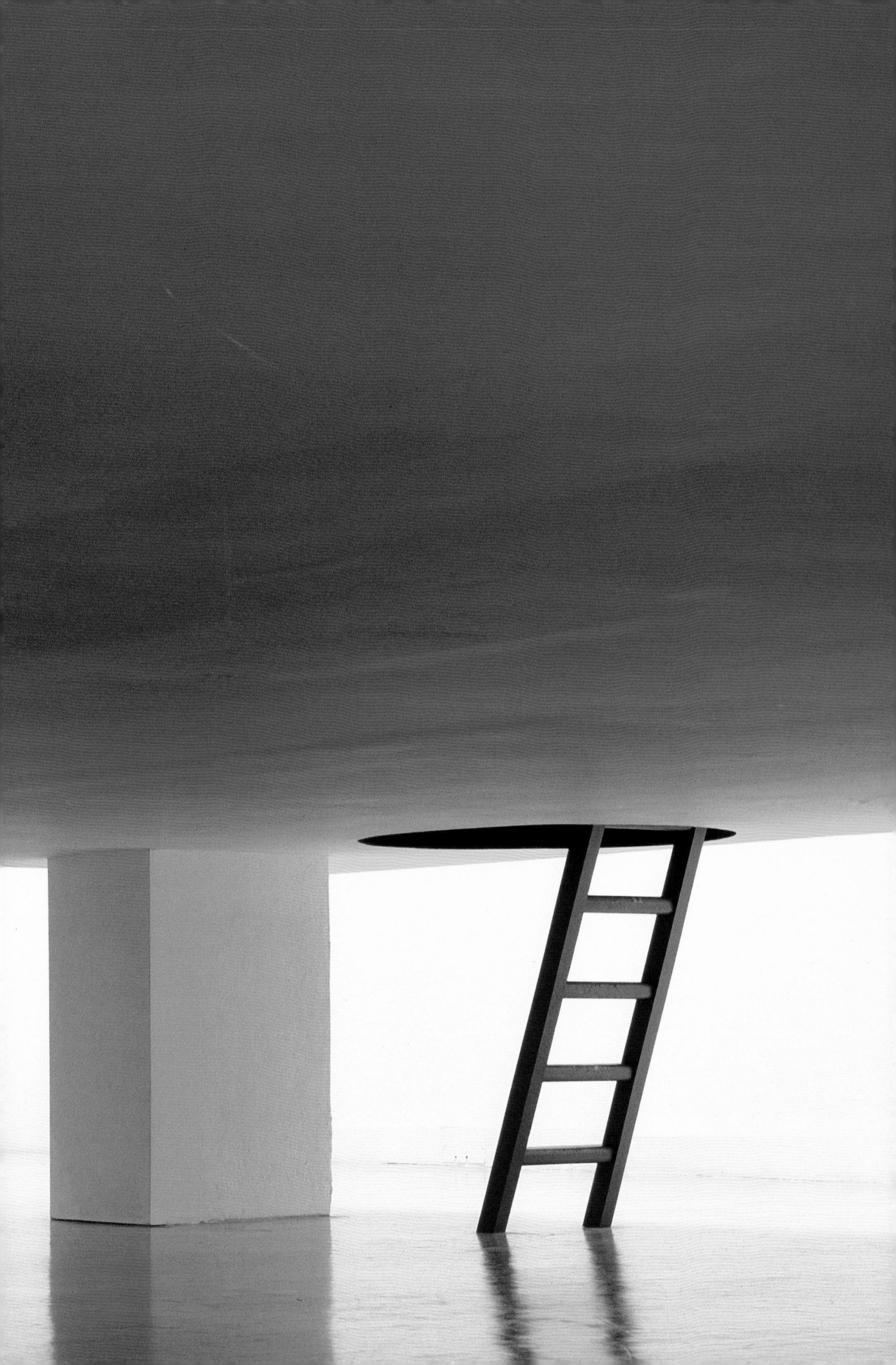

PROSTHESIS IV (LEFT ARM), 2000

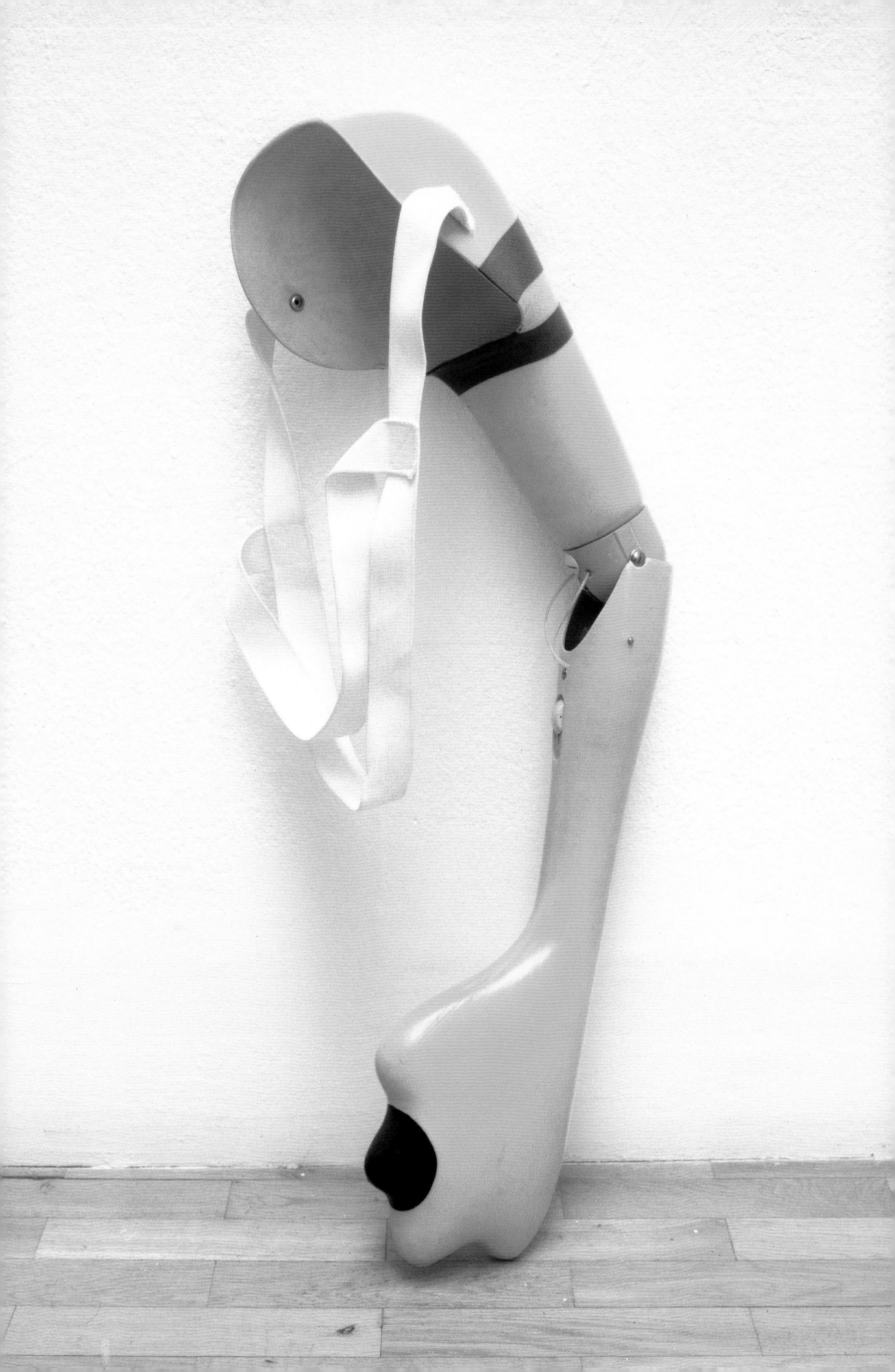

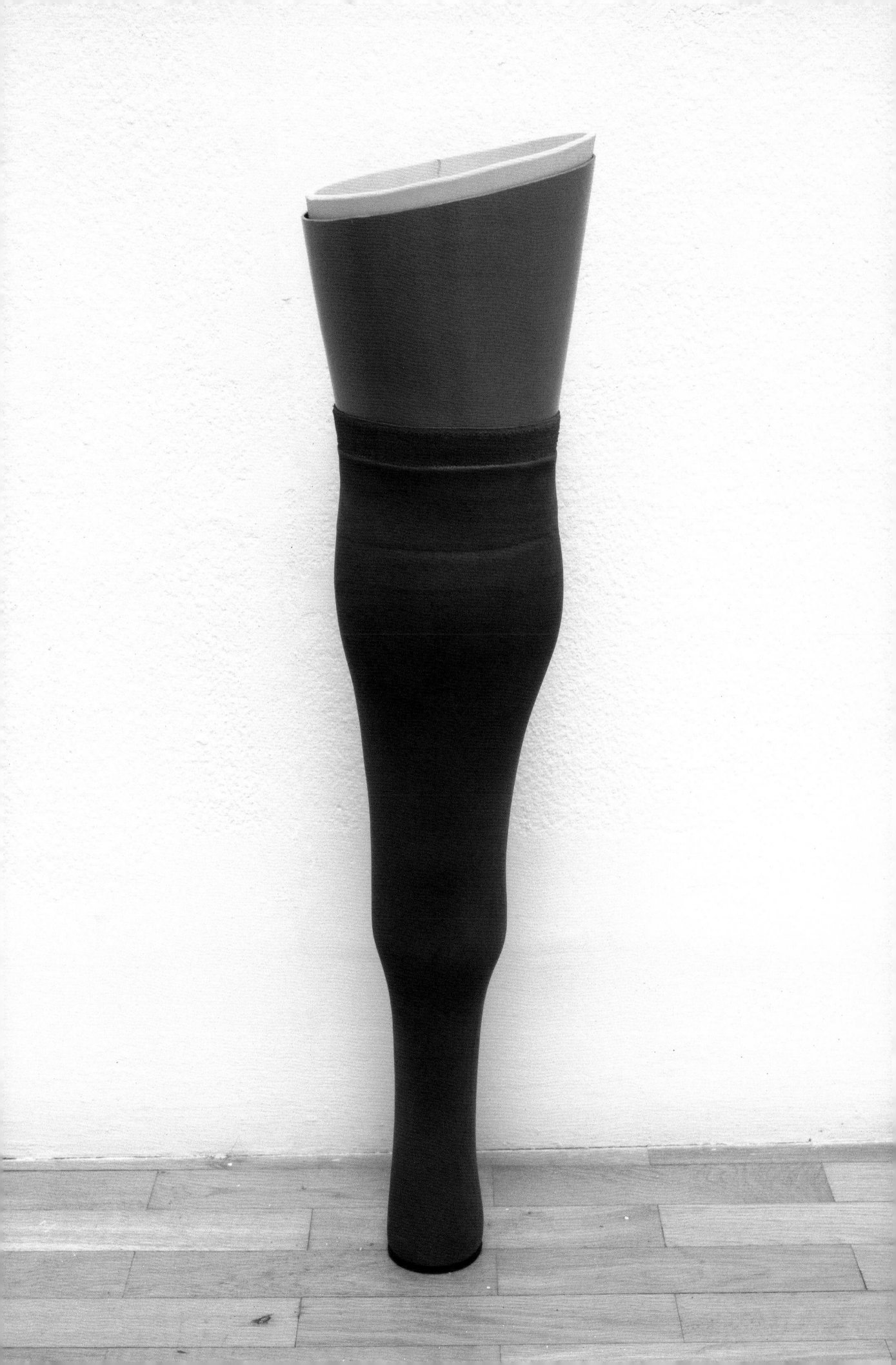

PROSTHESIS V (RIGHT ARM), 2000

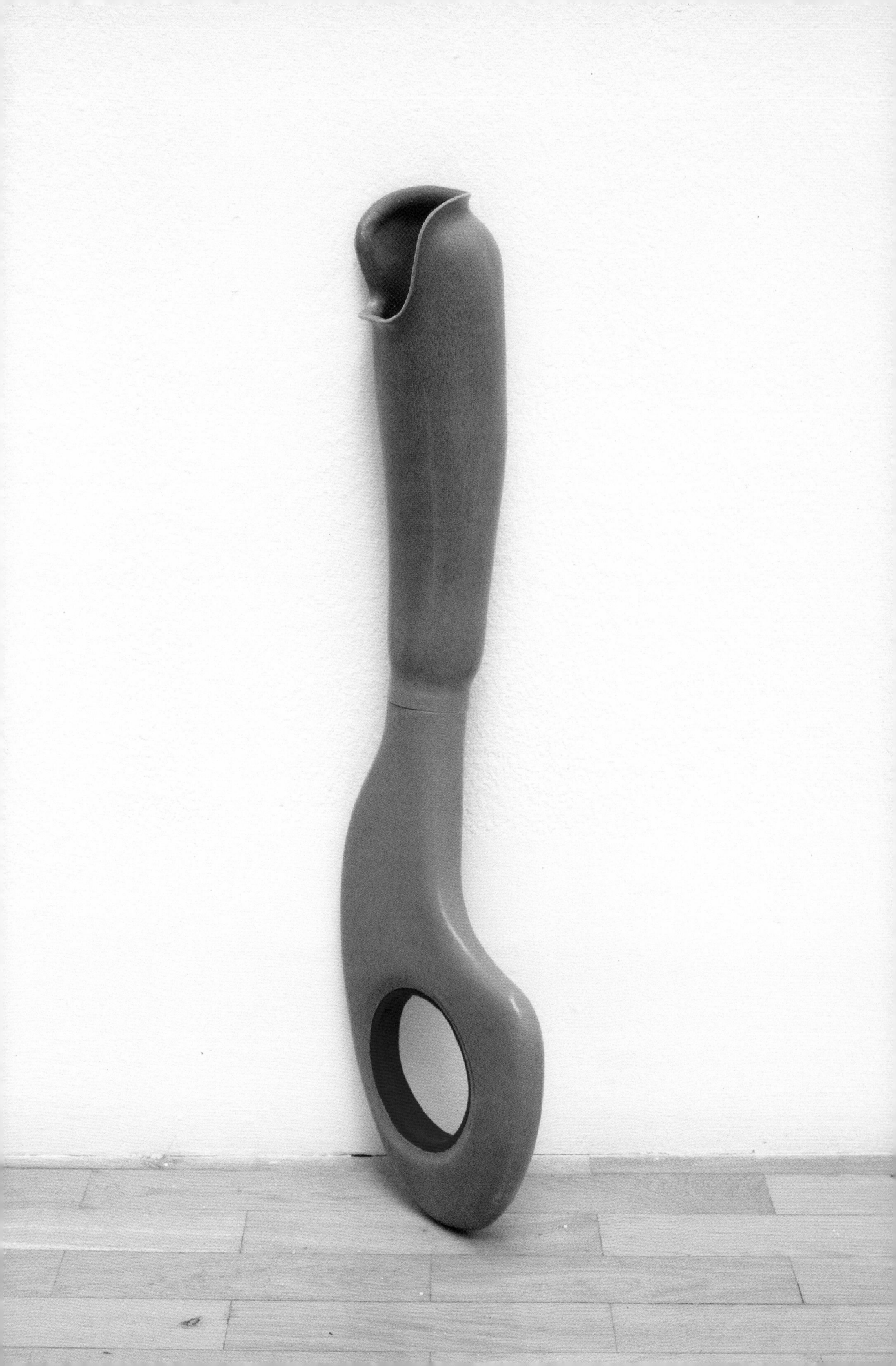

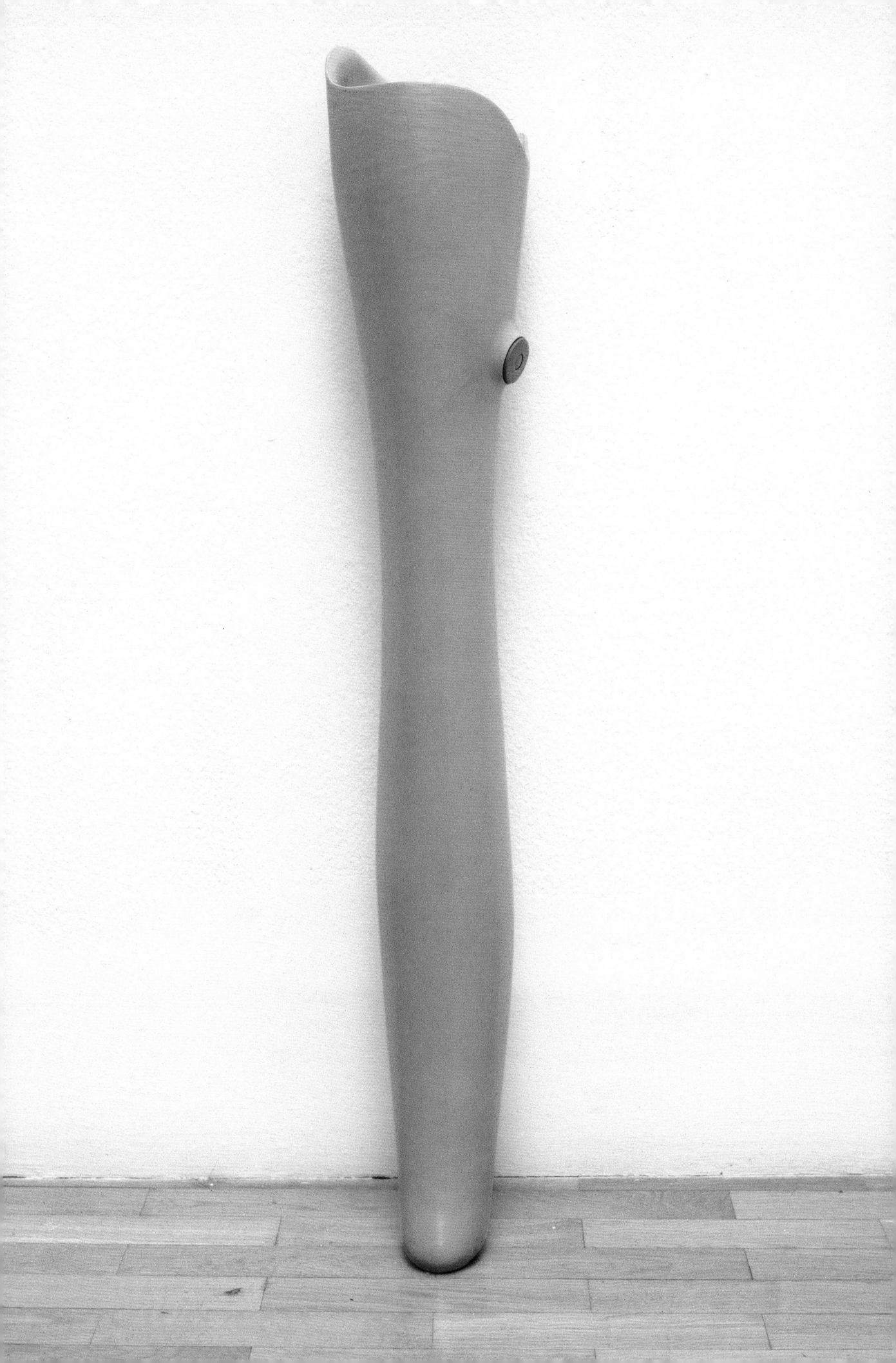

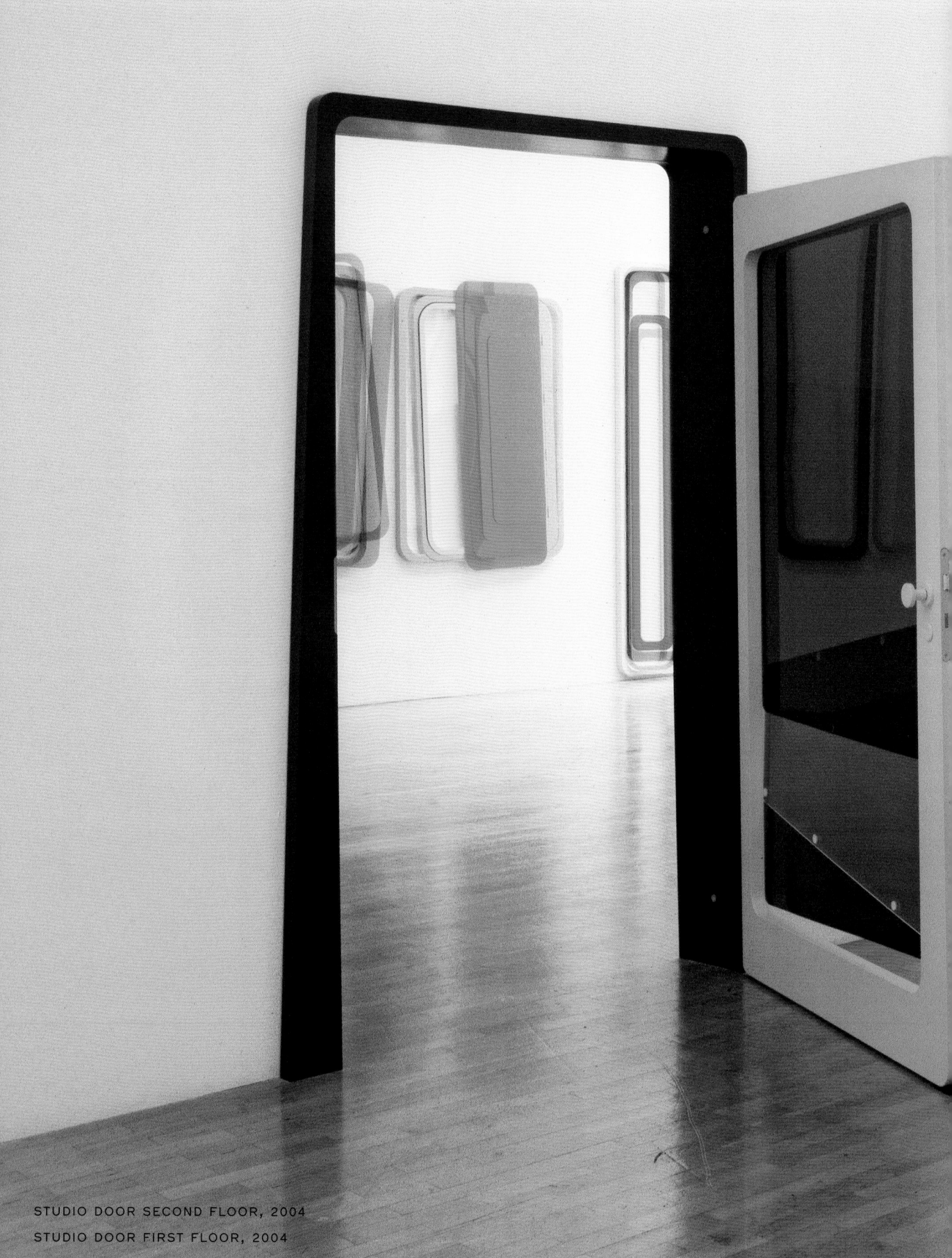

STUDIO DOOR SECOND FLOOR, 2004
STUDIO DOOR FIRST FLOOR, 2004

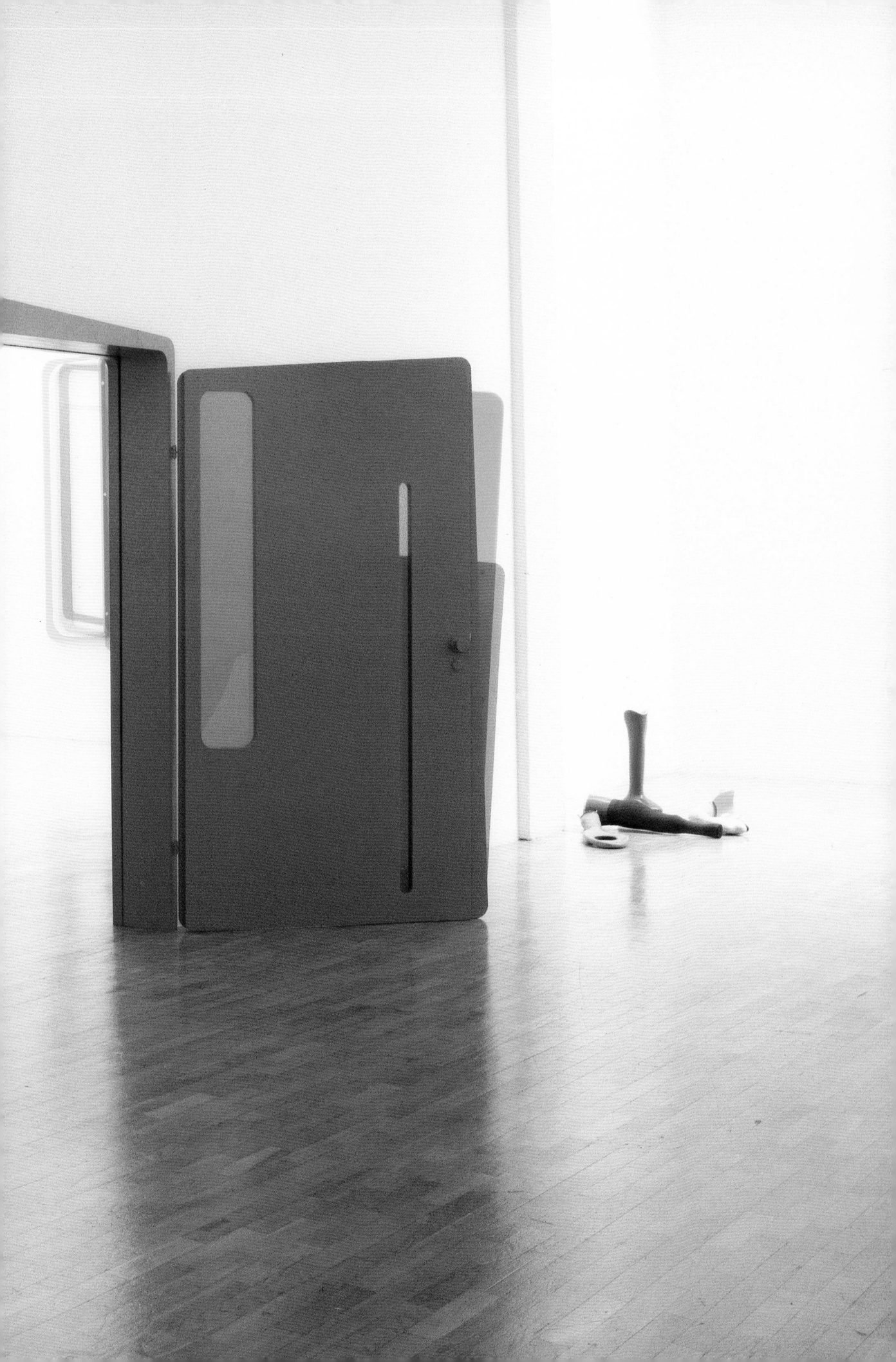

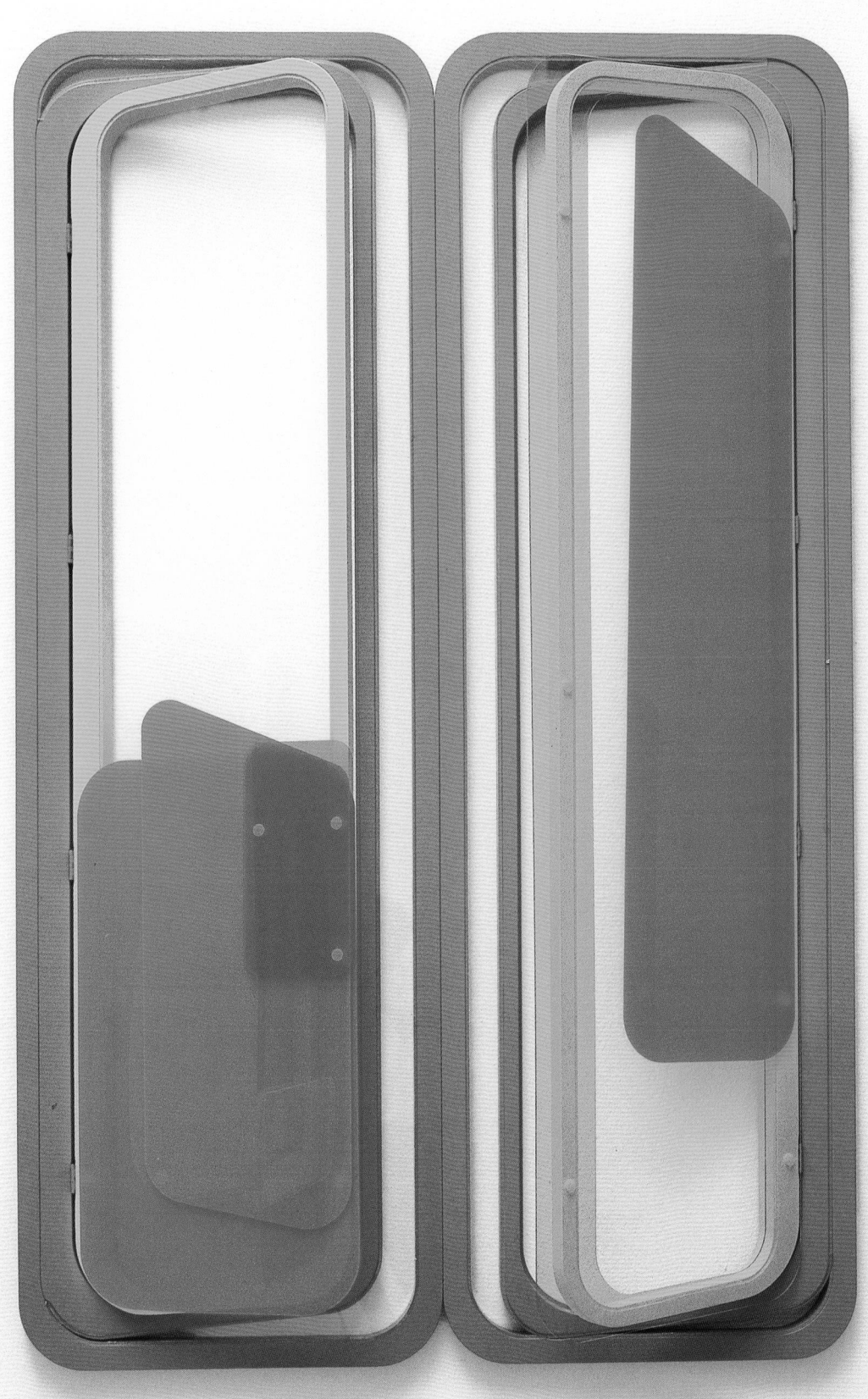

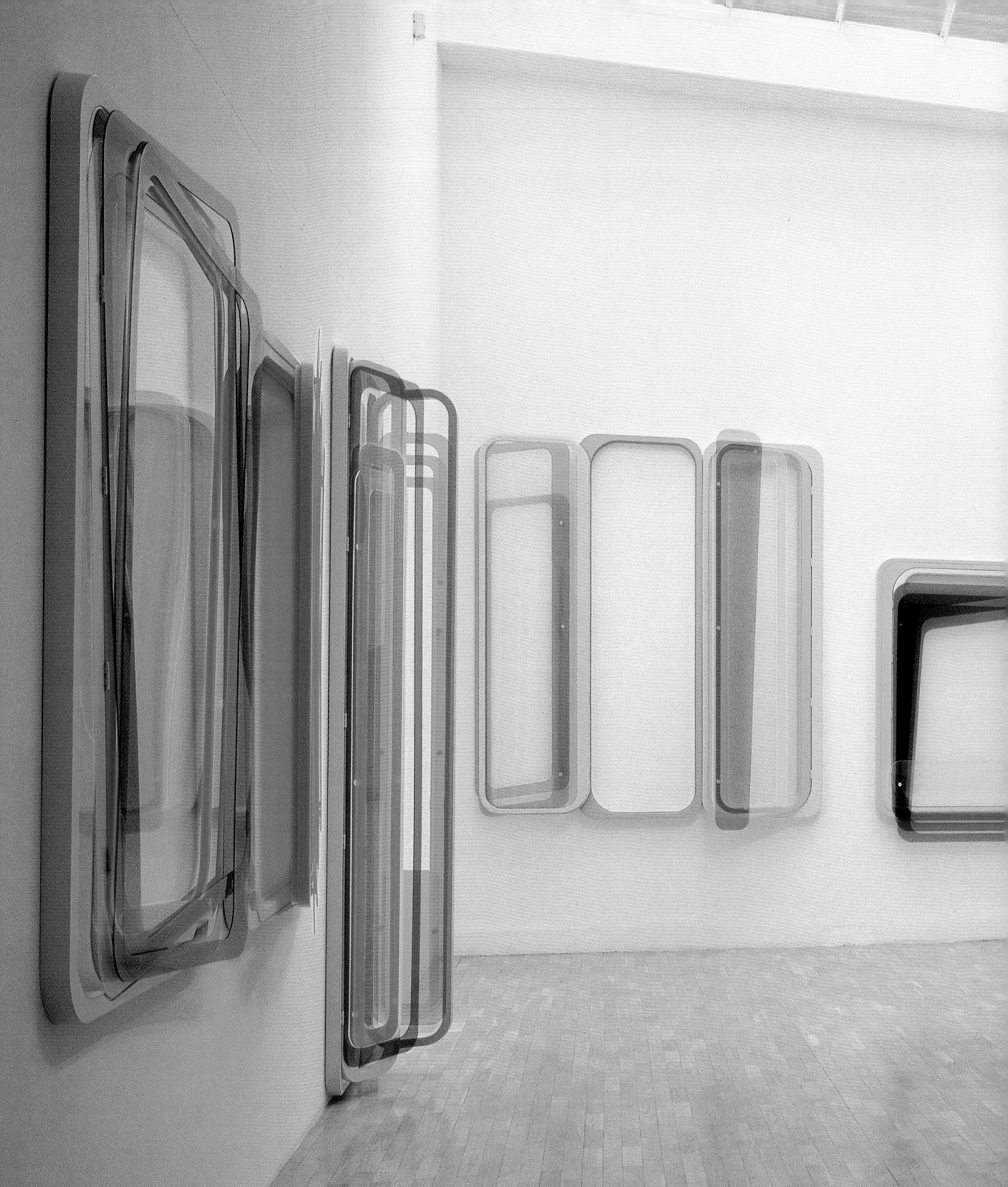

INSTALLATION VIEW, 2004

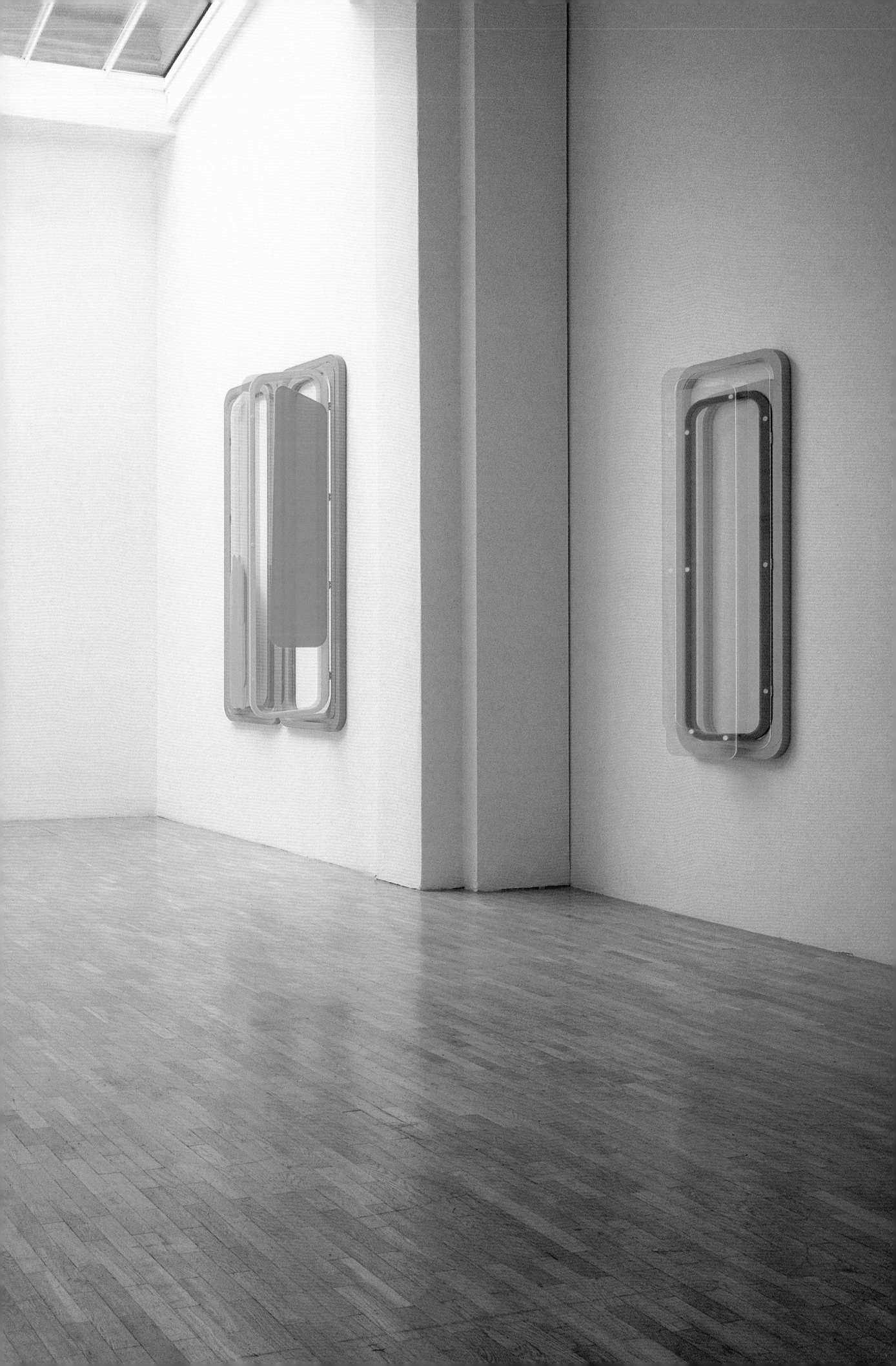

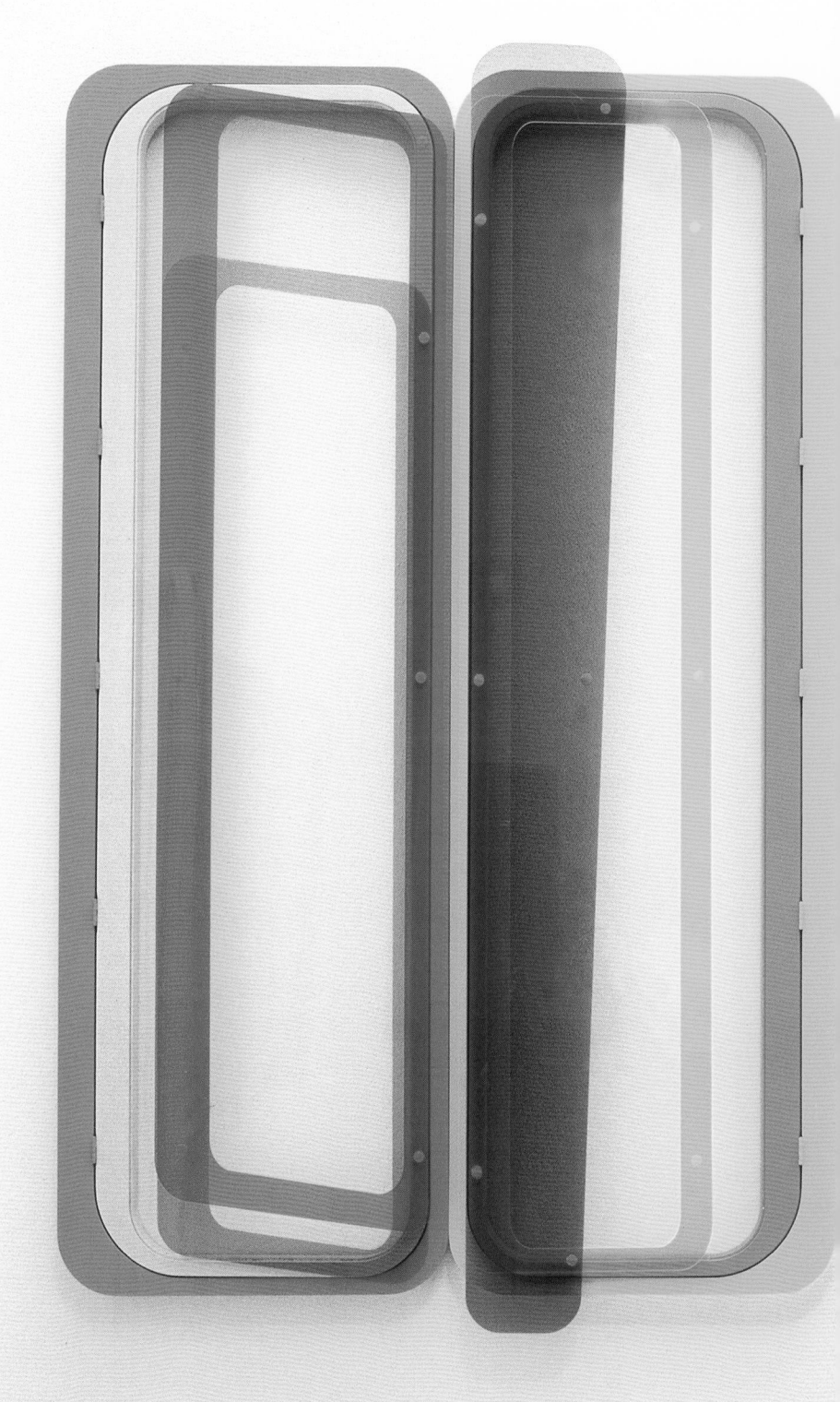

FR5 STUDIO WINDOW, 2004
G1 STUDIO WINDOW, 2004

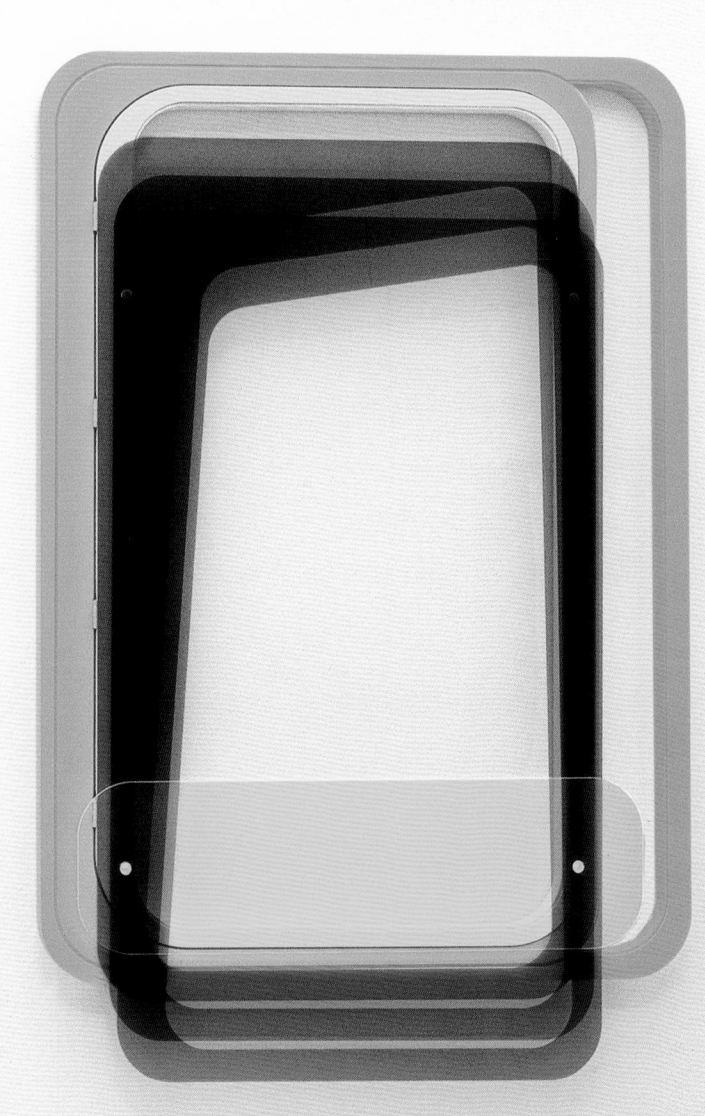

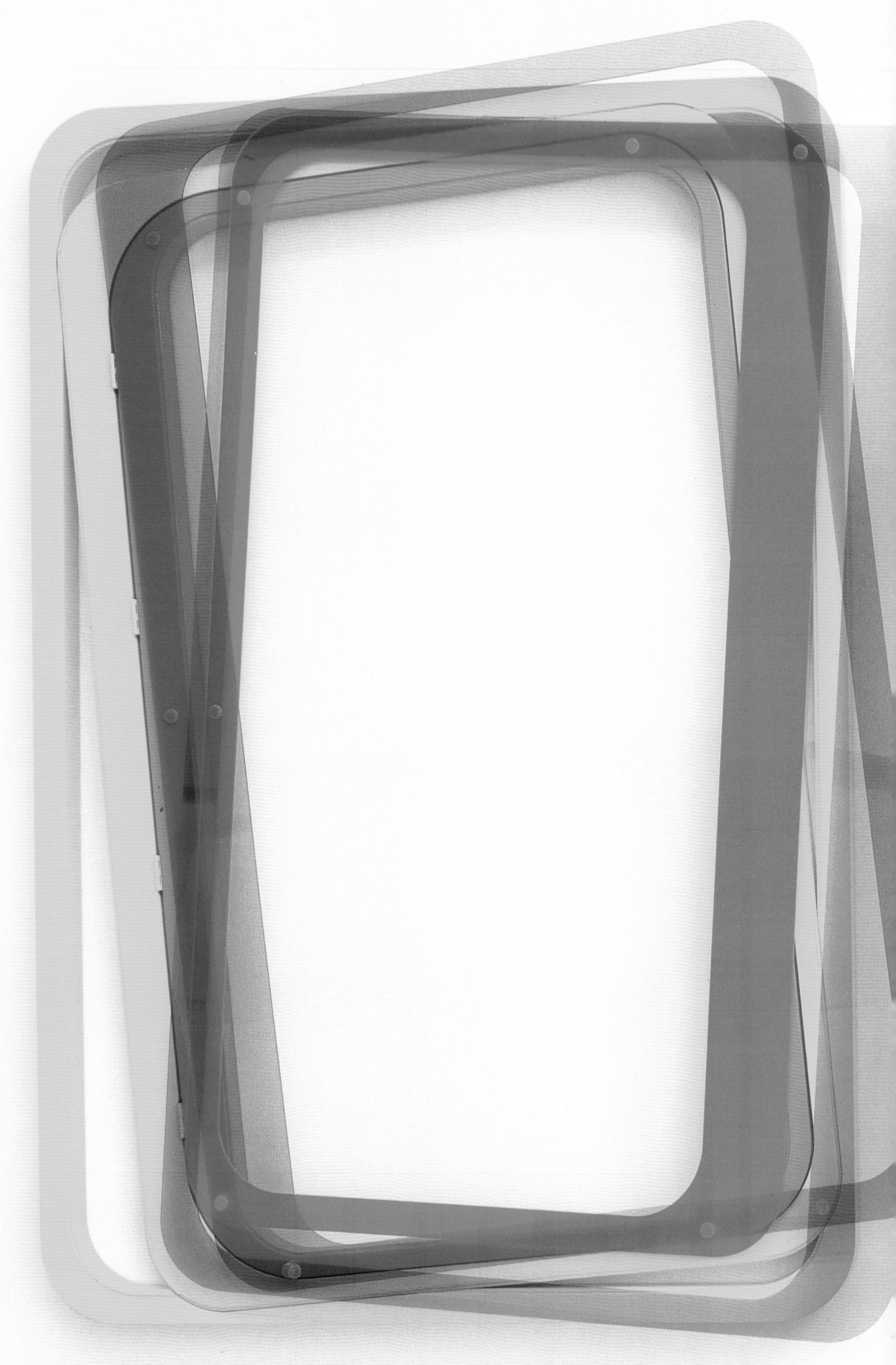

HZ1 STUDIO WINDOW, 2004

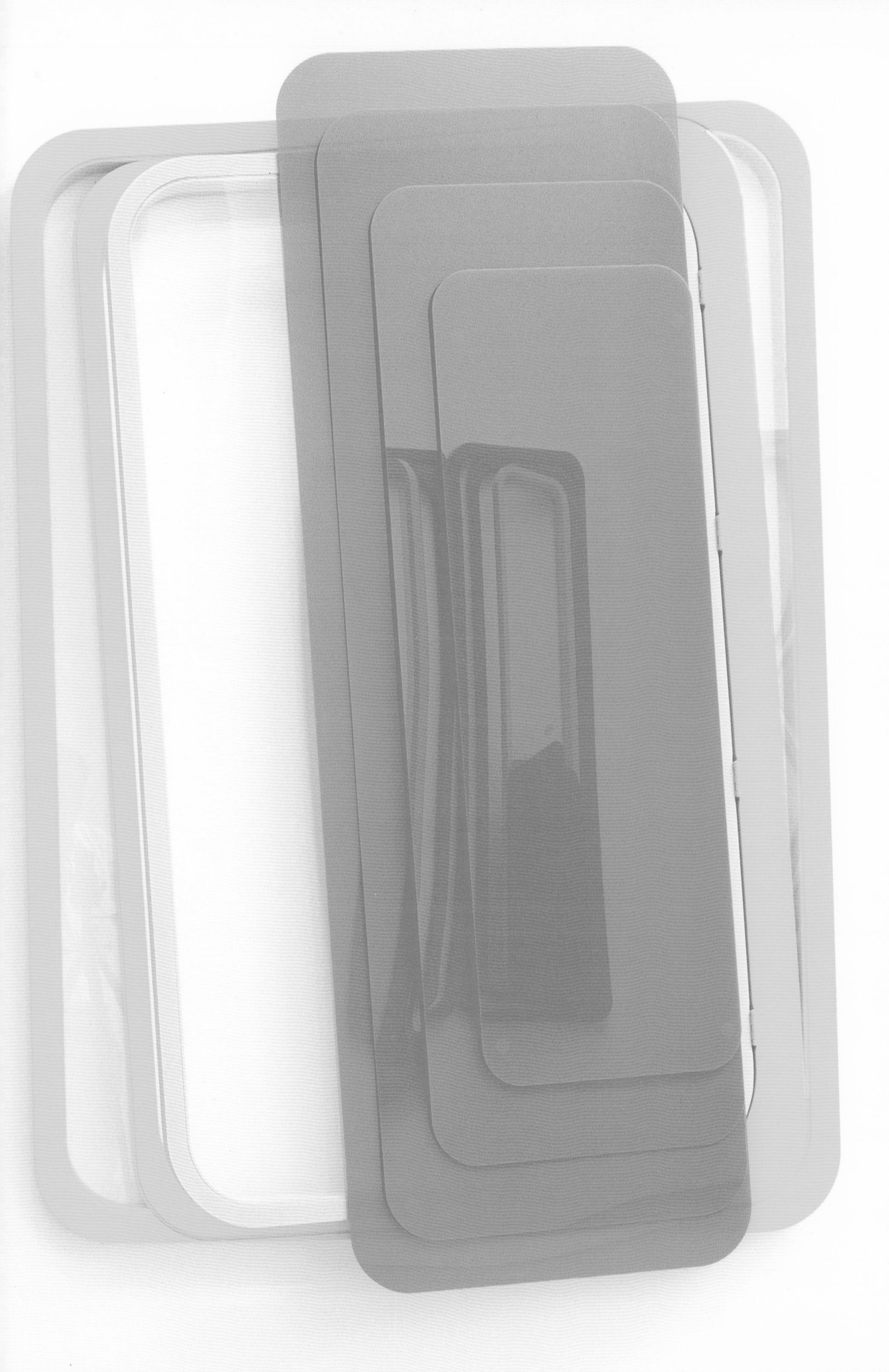

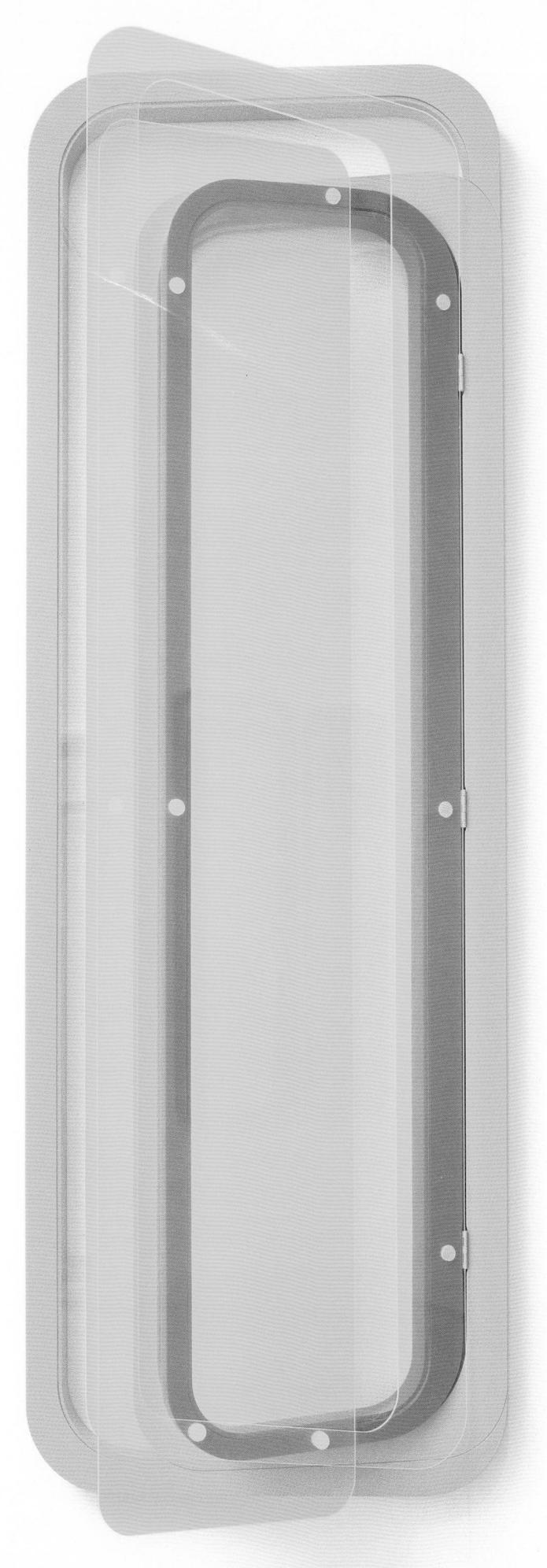

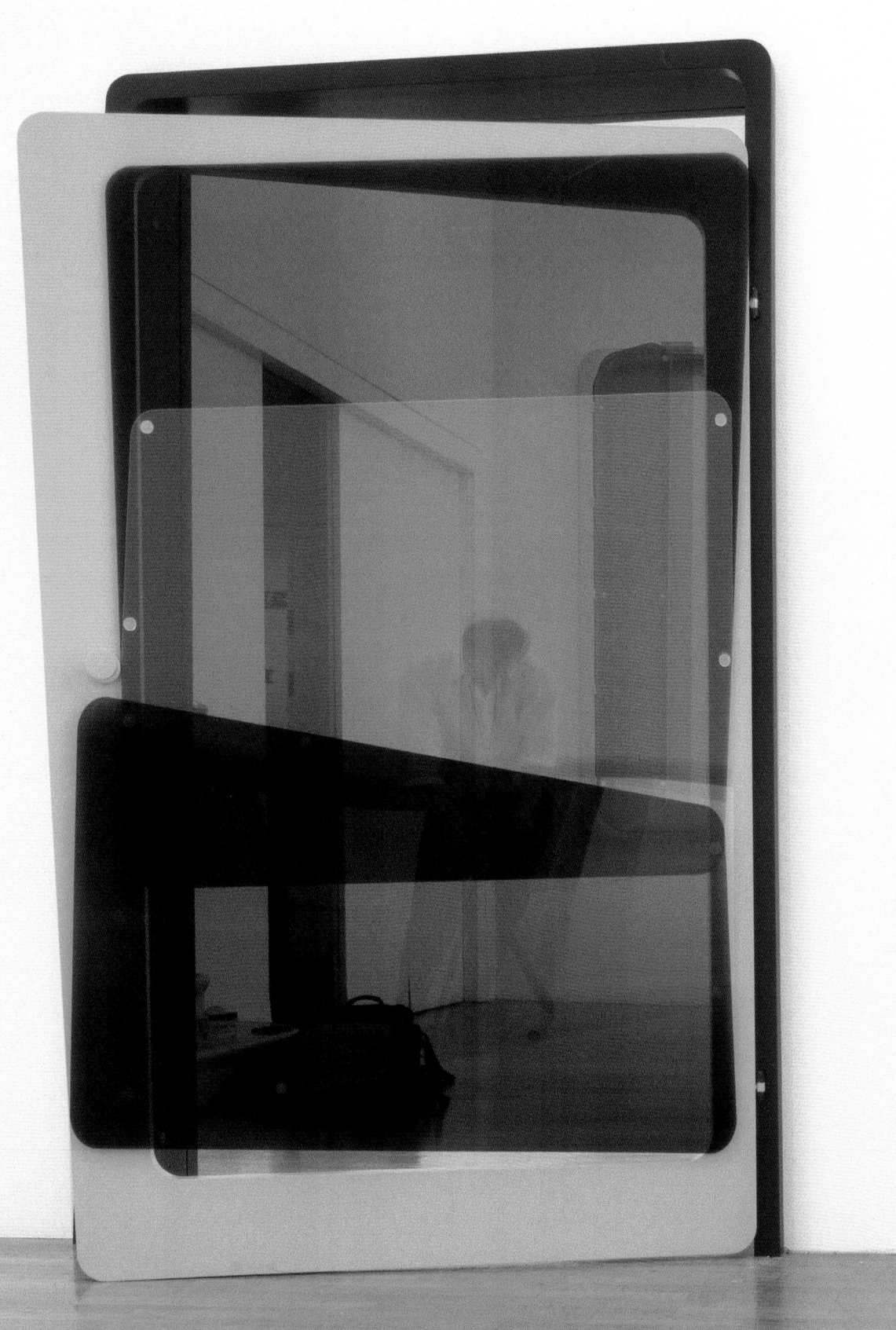

STUDIO DOOR SECOND FLOOR, 2004
STUDIO DOOR FIRST FLOOR, 2004

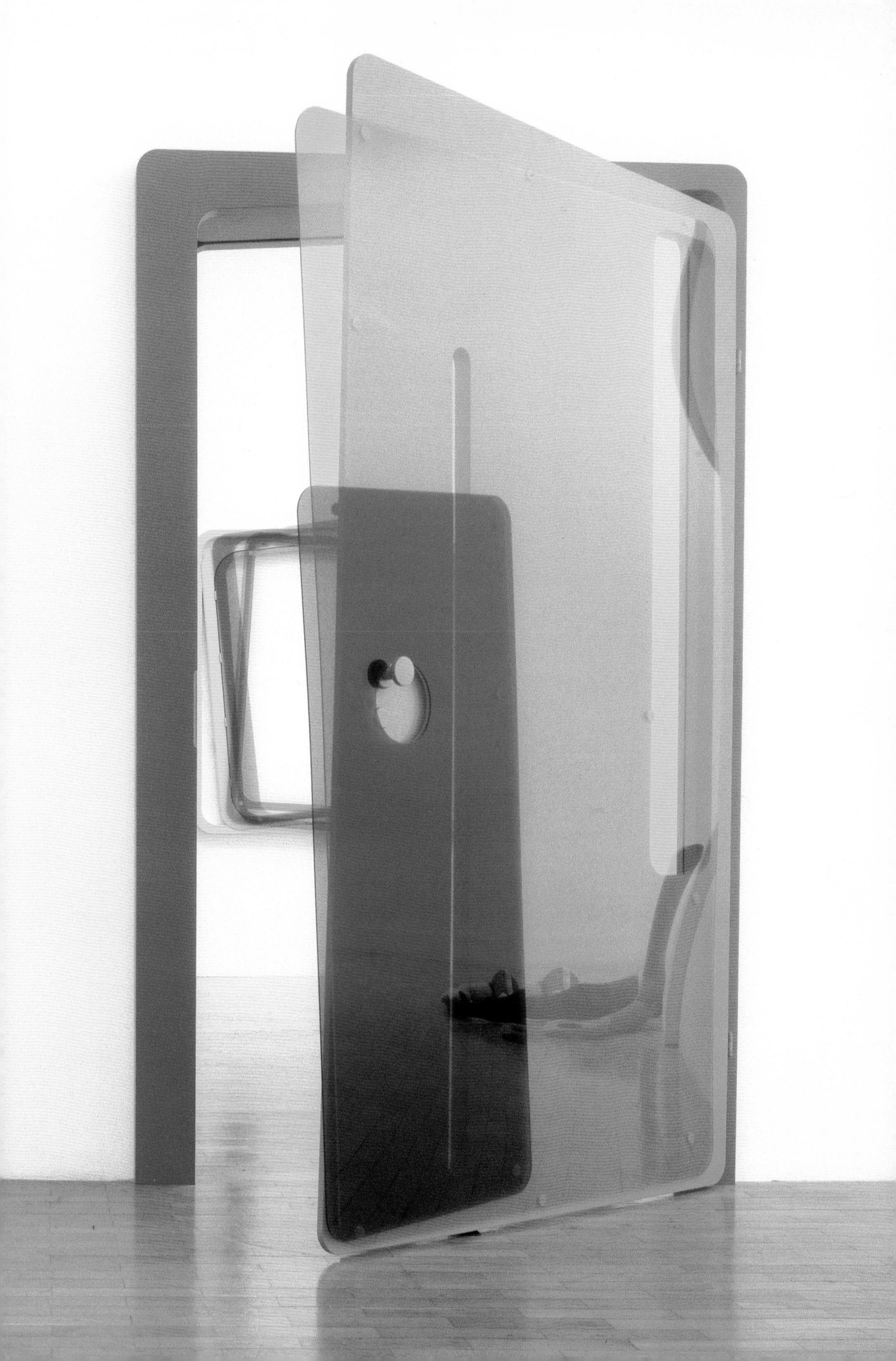

ADS 2, THE ROCK AND SOLE PLAICE
Poster printed on Seiko on blueback
poster paper
76 x 51
Courtesy the artist

ADS 2, BACH RESCUE CREAM
Poster printed on Seiko on blueback
poster paper
76 x 51
Courtesy the artist

ADS 2, DJ KOZE
Poster printed on Seiko on blueback
poster paper
76 x 51
Courtesy the artist

ADS 2, FIAT PANDA
Poster printed on Seiko on blueback
poster paper
76 x 51
Courtesy the artist

ADS 2, ZIMMERLI
Poster printed on Seiko on blueback
poster paper
76 x 51
Courtesy the artist

UP ON 1–5, 2004
Ink on paper, wallpaper
Dimensions variable
neugerriemschneider, Berlin

ME SHELL. AS PUMPKIN VERSION, 2004
Mixed media
C. 300 x 700 x 1000
neugerriemschneider, Berlin

PROSTHESIS I (FINGER), 2004
Mixed media
5 x 17 x 6
Galleria Gio Marconi, Milan

PROSTHESIS II (LEFT LOWER LEG), 2000
Mixed media
75 x 18 x 18
Galleria Gio Marconi, Milan

PROSTHESIS III (FOOT), 2004
Mixed media
7 x 17 x 20
Galleria Gio Marconi, Milan

PROSTHESIS IV (LEFT ARM), 2000
Mixed media
69 x 21 x 10
Private Collection Belgium

PROSTHESIS V (RIGHT ARM), 2000
Mixed media
87 x 25 x 18
Galleria Gio Marconi, Milan

PROSTHESIS VI (LEFT KNEE), 2000
Mixed media
75 x 18 x 18
Galleria Gio Marconi, Milan

PROSTHESIS VII (RIGHT LEG), 2000
Mixed media
98 x 16 x 17
Fondazione Sandretto Re Rebaudengo,
Turin

FR3 STUDIO WINDOW, 2004
MDF and Perspex
Each side 237 x 77 x 7
neugerriemschneider, Berlin

HZ1 STUDIO WINDOW, 2004
MDF and Perspex
Each side 180 x 130 x 7
Friedrich Petzel Gallery, New York

G2 STUDIO WINDOW, 2004
MDF and Perspex
180 x 123 x 7
neugerriemschneider, Berlin

K1 BALCONY DOOR, 2004
MDF and Perspex
277 x 55 x 7
neugerriemschneider, Berlin

FR5 STUDIO WINDOW, 2004
MDF and Perspex
Each side 237 x 77 x 7
Galerie Bärbel Grässlin, Frankfurt

G1 STUDIO WINDOW, 2004
MDF and Perspex
180 x 123 x 7
neugerriemschneider, Berlin

FR4 STUDIO WINDOW, 2004
MDF and Perspex
Each side 237 x 77 x 7
Friedrich Petzel Gallery, New York

FR 1.1 STUDIO WINDOW, 2004
MDF and Perspex
195 x 67 x 7
neugerriemschneider, Berlin

STUDIO DOOR FIRST FLOOR, 2004
MDF and Perspex
C. 220 x 140 x 30
Galerie Bärbel Grässlin, Frankfurt

STUDIO DOOR SECOND FLOOR, 2004
MDF and Perspex
C. 220 x 140 x 30
neugerriemschneider, Berlin

All dimensions in cm, height x width x depth

Biography

Born 1966
in Esslingen, Neckar
Lives and works in Frankfurt

EDUCATION
Hochschule für Bildende Kunst, Frankfurt

SOLO EXHIBITIONS

2004
Private Matters, Whitechapel Gallery,
London, GB
Artsonje Center, Seoul, Korea

2003
Galerie Ghislaine Hussenot, Paris, France
"bitte danke", works by Tobias Rehberger
from the Landesbank Baden-Württemberg
collection, Galerie der Stadt Stuttgart,
Stuttgart, Germany
Main Interiors, Galerie Micheline Szwajcer,
Antwerp, Belgium
*Die Zähne sind in Ordnung, aber das
Zahnfleisch geht zurück*, Galerie Heinrich
Ehrhardt, Madrid, Spain

2002
Prescrições, descrições, receitas e recibos,
Museu Serralves, Porto, Portugal
Night Shift, Palais de Tokyo, Paris, France
Treballant/Trabajando/Arbeitend,
Fundacío "la Caixa", Barcelona, Spain
Deaddies, Galeria Civica d'Arte Moderna
e Contemporanea, GAM, Turin, Italy
geläut – bis ichs hör, Museum für neue
Kunst MKN, Karlsruhe, Germany
Mütter innen, von aussen, Galerie Bärbel
Grässlin, Frankfurt, Germany

2001
Tobias Rehberger ads, Galerie & Edition
Artelier, Graz, Austria
Do Not Eat Industrially Produced Eggs,
Förderpreis zum Internationalen Preis
des Landes Baden-Württemberg,
Staatliche
Kunsthalle, Baden-Baden, Germany
DIX-Preis 2001, Kunstsammlung
Gera – Orangerie, Gera, Germany
Viafarini, Milan, Italy
(whenever you need me), Westfälischer
Kunstverein, Münster, Germany

2000
nana, neugerriemschneider, Berlin,
Germany
dusk, Galeria Gio Marconi, Milan, Italy
The Sun from Above, Museum of
Contemporary Art, Chicago, USA
Galerie Ghislaine Hussenot, Paris, France

Frac Nord – Pas de Calais,
Dunkerque, France
Jack Lemmon's Legs and Other Libraries,
Friedrich Petzel Gallery, New York, USA

1999
The Secret Bulb in Barry L., Galerie für
zeitgenössische Kunst, Leipzig, Germany
The Improvement of the Idyllic, Galeria
Heinrich Ehrhardt, Madrid, Spain
Sunny-side up, Matrix 180, University of
California, Berkeley Art Museum, USA
Holiday-Weekend-Leisure Time-Wombs,
Galerie Micheline Szwajcer, Antwerp,
Belgium
*fragments of their pleasant spaces
(in my fashionable version)*, Galerie
Bärbel Grässlin, Frankfurt, Germany
Standard Rad, Transmission Gallery,
Glasgow, GB
Nightprowler, De Vleeshal, Middelburg,
Netherlands

1998
Moderna Museet, Stockholm, Sweden
Kunsthalle Basel, Basel, Switzerland
*Waiting room – Also? Wir gehen? Gehen
wir!*, Intervention 13, Sprengel Museum,
Hanover, Germany
Roomade, Office Tower Manhattan Center,
Brussels, Belgium

1997
brançusi, neugerriemschneider, Berlin,
Germany
anastasia, Friedrich Petzel Gallery,
New York, USA

1996
*Suggestions from the Visitors of the Shows
#74 and #75*, Portikus,
Frankfurt, Germany
Peuè Seè e Faàgck Sunday Paòe,
Kölnischer Kunstverein, Cologne, Germany
*fragments of their pleasant spaces
(in my fashionable version)*, Galerie Bärbel
Grässlin, Frankfurt, Germany
neun skulpturen, Produzentengalerie,
Raum für Kunst, Hamburg, Germany
Wo man is gout loogy luckie,
Hammelehle+Ahrens, Stuttgart, Germany
canceled projects, Museum Fridericianum,
Kassel, Germany
one, neugerriemschneider, Berlin, Germany

1995
Rehbergerst, Galerie Bärbel Grässlin,
Frankfurt, Germany
Galerie Luis Campaña, Cologne, Germany
Galerie & Edition Artelier, Graz, Austria
Goethe-Institut Yaoundé, Cameroons

1994
Sammlung Goldberg/The Iceberg Collection,
Ludwig Forum für internationale Kunst,
Aachen, Germany

1993
9 Skulpturen, Wohnung K. König,
Frankfurt, Germany

GROUP EXHIBITIONS

2004
Trafic d'influences: Art & Design, Collection
Frac Nord – Pas de Calais, Lille, France
Braunschweig Parcours, Kulturinstitut
Braunschweig, Braunschweig, Germany
Garten Eden, Galerie Bärbel Grässlin,
Frankfurt, Germany
Group show, Dépendance, Brussels,
Belgium
Kunst ein Kinderspiel, Schirn Kunsthalle
Frankfurt, Frankfurt, Germany
Suburban House Kit, Deitch Projects,
New York, USA
Werke aus der Sammlung Boros, Museum
für neue Kunst, ZKM, Karlsruhe, Germany

2003
Grazie, Hochschloss, Stiftung Schloss
Dyck, Jüchen, Germany
*Plastik, Plüsch und Politik. Reflexe der
70er Jahre in der Gegenwartkunst*,
Städtische Galerie, Norhorn, Germany
Outlook, 'The Factory', Athens School
of Fine Arts, Athens, Greece
*Add to it. Louise Lawler (pictures),
Olafur Eliasson & Zumtobel Staff (light),
Tobias Rehberger (space)*, Portikus
im Leinwandhaus, Frankfurt, Germany
Form-Specific, Moderna Galerija,
Ljubljana, Slovenia
Micro-Utopias, 1. Bienal de Valencia,
Valencia, Spain
*Cover Theory. Contemporary Art As
Re-Interpretation*, Officina della Luce.
ex Centrale Emilia, Piacenza, Italy
Soziale Fassaden U.A., Städtische Galerie
im Lehnbachhaus, Munich, Germany
*Dreams and Conflicts – The Viewer's
Dictatorship*, Biennale di Venezia,
Venice, Italy
actionbutton, Hamburger Bahnhof,
Berlin, Germany

2002
Thisplay, Colección Jumex, Mexico DF,
Mexico
the object sculpture, The Henry Moore
Institute, Leeds, GB
EU2, Stephen Friedman Gallery, London, GB
do it, curated by Hans Ulrich Obrist,
www.e-flux.com
40 Jahre Fluxus und die Folgen;
Nassauischer Kunstverein und
Projektbüro des Stadtmuseums Wiesbaden,
Wiesbaden, Germany
Hossa. Arte Alemán del 2000, Centro
Cultural Andratx, Mallorca, Spain

2001
Kunst zwischen Vision und Alltag, Wilhelm-
Hack-Museum, Ludwigshafen, Germany
Mínim Denominador Común, Sala
Montcada de la Fundació "la Caixa",
Barcelona, Spain

Come-in, Institut für Auslandsbeziehungen,
Stuttgart, Germany
Televisions, Kunst sieht fern, Kunsthalle
Wien, Vienna, Austria
Präsentation der Jahresgaben,
Westfälischer Kunstverein, Münster,
Germany
New Heimat, Frankfurter Kunstverein,
Frankfurt, Germany
ads, Galerie & edition artelier,
Graz, Austria
Artifical Natural Networks, de Verbeelding,
Zeewolde, Netherlands
Frankfurter Positionen, Portikus,
Frankfurt, Germany
ambiance magasin, Centre d'art
contemporain, Meymac, France
Electrify me, Friedrich Petzel Gallery,
New York, USA
Frankfurter Kreuz, Schirn Kunsthalle
Frankfurt, Frankfurt, Germany
Arbeit, Kokerei Zollverein, Essen, Germany
Serigrafien 1994–2001, Galerie Edition
Stalzer, Vienna, Austria
Plug in, Westfälisches Landesmuseum,
Münster, Germany
Freestyle, Werke aus der Sammlung
Boros, Museum Morsbroich,
Leverkusen, Germany
Hommage an Olle Baertling, Kunsthalle
Kiel, Kiel, Germany

2000
Finale di Partita, Chiostro di Ognissanti,
Florence, Italy
more works about buildings and food,
Fundição de Oeiras, Hangar K7, Portugal
turas amuebladas- furnished paintings,
galeria OMR, Mexico City, Mexico
Project #0004, Friedrich Petzel Gallery,
New York, USA
Berlin – Binnendifferenz, Galerie
Krinzinger, Vienna, Austria
Circles °2, Zentrum für Kunst und
Medientechnologie, Karlsruhe, Germany
Art For a Better Life, Lothringer 13/Halle,
Munich, Germany
Face-à-Face, kunstpanorama, Luzern,
Switzerland
Raumkörper, Kunsthalle Basel, Basel,
Switzerland
waiting, mjellby konstgård, Halmstad,
Sweden
ein/räumen – Arbeiten im Museum,
Hamburger Kunsthalle, Hamburg, Germany
Sensitive-Printemps de Cahors, Fondation
Cartier Pour l'Art Contemporain,
Ville de Cahors, France
The Sky is the Limit, Taipei Biennale, Taipei,
Taiwan
*Skulptur als Möbel – Möbel als Skulptur,
Objekte und Graphiken aus der Sammlung
der Neuen Galerie Graz*, Kloster
Frohnleiten, Austria
Micropolitiques, MAGASIN – Centre National
d'Art Contemporain, Grenoble, France

1999
Blown Away, 6th International Caribbean Biennal, St. Kitts, Caribbean Islands
Think Twice, Galería OMR, Mexico City, Mexico
German Open, Kunstmuseum Wolfsburg, Wolfsburg, Germany
Tableaux et Sculptures, Galerie Ghislaine Hussenot, Paris, France
Die Schule von Athen, Municipality of Athens – Technopolis, Athens, Greece
kraftwerk BERLIN, Aarhus Kunstmuseum, Aarhus, Denmark
Arte All'Arte, Arte Continua, Colle di Val d'Elsa, Italy
zoom, Sammlung Landesbank Baden-Württemberg, Stuttgart, Germany
Museum Abteiberg, Mönchengladbach, Kunsthalle zu Kiel, Kiel, Germany
Skulptur-Biennale 1999, Münsterland, Germany
wonder world – notes for a solid collection, newsantandrea, Savona, Italy
les deux saules pleureurs, Kunst-Werke, Berlin, Germany
amAzonas Künstlerbücher, Villa Minimo, Hanover, Germany
Ain't Ordinarily So, curated by Daniel Birnbaum, Casey Kaplan, New York, USA
Who, if not we?, Elizabeth Cherry Contemporary Art, Tucson, Arizona, USA
Further Fantasy, curated by Francesco Bonami, Galleria Giò Marconi, Italy
de coraz(i)on, Tecla Scala, Barcelona, Spain
Konstruktionszeichnungen, Kunst-Werke, Berlin, Germany

1998
Dad's Art, neugerriemschneider, Berlin, Germany
'___, 1994untitled, 1994 (meettim&burkhard)brançusi, 1997', Grazer Kunstverein, Graz, Austria
Round About Waves, curated by Adam Szymczyk, Ujadowski Castle, Warschau, Poland
weather everything, Galerie für zeitgenössische Kunst, Leipzig, Germany
minimalisms 1, Akademie der Künste, Berlin, Germany
[Collection 98], Galerie für zeitgenössische Kunst, Leipzig, Germany
Stephen Prina & Tobias Rehberger, Friedrich Petzel Gallery, New York, USA
manifesta 2, Luxemburg
Fuori Uso '98, Assoziazione Culturale Arte Nova, Pescara, Italy
Kunst für Bundestagsneubauten, Deutscher Bundestag, Berlin, Germany
Kunst und Papier auf dem Laufsteg, Deutsche Guggenheim Berlin, Germany
Lebensraum (ARKIPELAG), Stockholm, Sweden
Dramatically Different, MAGASIN – Centre National d'Art Contemporain, Grenoble, France

The Happy End of Franz Kafka's Amerika, works on paper, inc., Los Angeles, USA

1997
Kunst...Arbeit, Südwest LB, Stuttgart, Germany
M&M, Fondazione Re Rebaudengo, Turin, Italy
Heaven, P.S.1, New York, USA
Beyond the auratic object, Philomene Magers, Cologne, Germany
Time Out, Kunsthalle Nürnberg, Nuremburg, Germany
Frankfurt(M)-Kassel-Münster, Galerie Bärbel Grässlin, Frankfurt, Germany
Truce: Echoes of Art in an Age of Endless Conclusions, Site Santa Fe, Santa Fe, USA
assuming positions, Institute of Contemporary Arts, London, GB
future – present – past, Biennale de Venezia, Venice, Italy
Dieci Artisti Tedeschi per Verona, Verona, Italy
skulptur. projekte in Münster '97, Münster, Germany
Giò Marconi, Milan, Italy
garnish and landscape, Gesellschaft für Gegenwartskunst, Augsburg, Germany
Rooms with a View: Environments for Video, Guggenheim Museum SoHo, New York, USA
Fort! Da!, Villa Merkel, Esslingen, Germany
Campo 6, The Spiral Village, curated by Francesco Bonami, Bonnefantenmuseum, Maastricht, Netherlands

1996
Heetz, Nowak, Rehberger, Städtisches Museum Abteiberg, Mönchengladbach, Germany
Campo 6, Fondazione Sandretto Re Rebaudengo per l'Arte, Galleria Civica d'Arte Moderna di Torino, Turin, Italy
nach weimar, Kunstsammlungen zu Weimar, Weimar, Germany
Alle Neune, ACC Galerie, Weimar, Germany
almost invisible/fast nichts, Umspannwerk Singen, Singen/Hohentwiel, Germany
Manifesta 1, Rotterdam, Netherlands
Dites-le avec des fleurs, Galerie Chantal Crousel, Paris, France
something changed, Helga Maria Klosterfelde, Hamburg, Germany
Der Umbau Raum, Künstlerhaus Stuttgart, Stuttgart, Germany
Cruise, curated by Florian Waldvogel, Friedensallee 12, Hamburg, Germany
Kunst in der neuen Messe Leipzig, Leipzig, Germany
Zum Gebrauch bestimmt, Galerie Sophia Ungers, Cologne, Germany

1995
Regal, Regal, curated by Florian Waldvogel, Forum, Frankfurt, Germany

Städelschule im BASF-Feierabendhaus, Ludwigshafen, Altenburg, Germany
Bed & Breakfast, Ivor Evans Hall, London, GB
filmcuts, neugerriemschneider, Berlin, Germany
Villa Werner, Offenbach, Germany
... kommt mit seinen Gaben, Museum Abteiberg, Mönchengladbach, Germany
Alles was modern ist, Galerie Bärbel Grässlin, Frankfurt, Germany

1994
Stipendiaten der Frankfurter Künstlerhilfe e.V., Galerie ak, Frankfurt, Germany
WM Karaoke, Portikus, Frankfurt, Germany/London, GB
Men's World, Künstlerkreis Ortenau, Offenburg, Germany
Stadt/Bild, Karmeliterkloster, Frankfurt, Germany
WM-Karaoke, Portikus, Frankfurt, Germany/London, GB
Backstage, Kunstmuseum Luzern, Lucerne, Switzerland

1993
Backstage, Hamburger Kunstverein, Hamburg, Germany
Es ist eine Zeit hereingebrochen, in der alles möglich sein sollte, Kunstverein Ludwigsburg, Villa Franck, Germany

1992
Dealing with Art, Künstlerwerkstatt Lothringer Strasse, Munich, Germany
SS.SS.R., Galerie Bärbel Grässlin, Frankfurt, Germany
Virtuosen vor dem Berg, Galerie Grässlin/Erhardt, Frankfurt, Germany
Spielhölle, Ästhetik u. Gewalt, Frankfurt, Germany
Qui, quoi, où?, Musée d'Art Moderne de la Ville de Paris, Paris, France

1991
Zwischen Dürer und Holbein, Städelschule, Frankfurt, Germany
Give me a hand before I call you back, Galerie Bleich-Rossi, Graz, Austria

BIBLIOGRAPHY

2004
Charlesworth, J.J., 'A Field of Many-Coloured Objects', *contemporary*, no.64.
Ward, Ossian, 'Tobias Rehberger', *contemporary*, no.64, p.90–93.
Piccoli, Cloe (interview), 'Tobias Rehberger', *Carnet*, April/May, p.66–73.
Schwarz, Sabine, 'Tobias Rehberger', in *Werke aus der Sammlung Boros*, exh. cat., ZKM, Karlsruhe.
Shaw, Francesca D. (interview), 'Tobias Rehberger. Meta-form and Meta-control', *Flash Art*, January/February, p.88–90.

2003
Grazie, exh. cat., Stiftung Schloss Dyck, Jüchen, Germany.
Rondeau, James, '50th Venice Biennale. Review', *Frieze*, September, p.96–97.
Vetrocq, Marcia E., 'Venice Biennale: "Every Idea But One"', *Art in America*, September.
Dunn, Melissa, 'The Venice Biennale: Slouching Toward Utopia', *Flash Art*, July–September.
Lorch, Catrin, 'La Biennale di Venezia', *Kunst-Bulletin*, July/August, p.22–27.
Händler, Ruth, 'Die Design-Künstler', *Häuser*, April, p.106–107.
Morineau, Camille, 'Yes, But Who Designed the Urinal?', *artpress*, no.287, February, p.39–49.

2002
treballant/trabajando/arbeitend, exh. cat., Fundació la Caixa, Barcelona.
Sans, Jérôme, 'Tobias Rehberger: Working With, Working Between', *artpress*, no.284, November, p.44–49.
Kuni, Verena, 'Im Duschbad des guten Willens', *Süddeutsche Zeitung*, 10 September.
Krenz, Marcel, 'Inside-out art', *Art Review*, vol.LIII, July/August.
McEwen, John, 'Exuberant colour and elephant dung', *Sunday Telegraph*, 7 July.
Sladen, Mark, 'The Object Sculpture', *Untitled*, no.28, summer.
Birnbaum, Daniel, 'Where is Painting now?', *Tate, international arts and culture*, September/October, p.61–63.
Müller, Irene, 'Tobias Rehberger im Museum für neue Kunst/ZKM, Karlsruhe', *Kunstbulletin*, no.7/8, p.64.
Morton, Tom, 'The Object Sculpture', *frieze*, September.
Brehm, Margrit; Cherubini, Laura; Pace, Alessandra (conversation with), *Deaddies. Tobias Rehberger*, exh. cat., Galeria d'Arte Moderna, Torino, Ed. Hopefulmonster.
Lledó, Elena, 'Tobias Rehberger', *Lapiz*, no.184, June, p.35–39.

Crüwell, Konstanze, 'Mutter Garage: Alte Automodelle und junge Kunst in Frankfurter Galerien', *Frankfurter Allgemeine Zeitung*, 23 February, no.46, p.56.
Imdahl, Georg, 'Gebührenpflicht', *Frankfurter Allgemeine Zeitung*, 15 February.
…(whenever you need me), exh. cat., Westfälischer Kunstverein, Münster.

2001
Hohmann, Silke, 'Heimat global', *Journal Frankfurt*, 26 October – 8 November.
Rehberger, Tobias, 'Zwei sehr schöne Dinge, auf die man in der Stadt treffen kann', in Matzner, Florian, *Public Art*, Hatje/Cantz, p.65–71.
Matzner, Florian; Tazzi, Pier Luigi; Birnbaum, Daniel; Bonami, Francesco; Müller, Marcus, *Tobias Rehberger, 005-000 [Pocket Dictionary]*, Matzner, Florian, Hatje/Cantz
Rönnau, Jens, 'Olle Bærtling', *Kunstforum International*, April–May, issue 154, p.385.
Bortolotti, Maurizio, 'Dopopaessagio', *July*, no.103, June, p.26–29.
Winkelmann, Jan, 'Met een koude kont naar Richard Serra kijken – een gesprek met Tobias Rehberger', *Metropolis M*, April/May, no.2, p.42–47.
Meneguzzo, Marco, 'Avventura oltre il Muro', *AD/Antiques& Collectors*, March, no.238.
Heidenreich, Stefan, 'Pflummis, springt auf diese Stadt!', *Frankfurter Allgemeine Zeitung*, 3 January.
Ermacora, Beate, *Olle Baertling, Retrospektive*, exh. cat., Kunsthalle Kiel.
Baldon, Diana, 'Ein/räumen in Hamburg', *tema celeste*, January/February, p.116.

2000
ein/räumen, exh. cat., Hamburger Kunsthallen.
Mühling, Matthias, 'Stille Kunstpost', *Der Tagesspiegel*, 9 December.
Meixner, Christiane, 'Heul doch!', *Berliner Morgenpost*, 5 December, p.19.
Stange, Raimar, '"ein/räumen" in der Hamburger Kunsthalle', *Kunstbulletin*, no.12.
Winter, Peter, 'Katzen, Kassen, Karl V', *Frankfurter Allgemeine Zeitung*, 20 November.
Scanlan, Joe, 'What's the Use', www.eyestorm.com
Blase, Christoph, 'Brutale Karre faucht durch Mitte', *Frankfurter Allgemeine Zeitung*, 20 November, no.270, p.BS3.
Langer, Freddy, 'Ab heute: Adorno und die Kunst, Rennautos zu kippen', *Frankfurter Allgemeine Zeitung*, 11 November, p.BS1.
Lacagnina, Salvatore, 'In Between at the Expo of Hanover, Interview with Wilfried Dickhoff', *tema celeste*, October–December, p.112.

'artwaresmart', *Portfolio*, Newsletter 2/2000, p.4–5.
Casadio, Mariuccia, 'Rehberger by Tobias Rehberger', *L'Uomo Vogue*, October.
Stange, Raimar, 'Kunst rund um die EXPO 2000', *Kunstbulletin*, September, no.9.
Wellfelt, Emilie, 'Mjellby konstgård visar upp konsten att vänta', *Hallandsposten*, 15 July.
Bergström, Lotta, 'Ett evig väntande', *Kultur Nöje*, 18 July.
Pakesch, Peter, *Raumkörper, Netze und andere Gebilde*, exh. cat., Kunsthalle Basel 38/2000, Basel.
Magerl, Sabine, 'Locker vom Hocker', *AD Architectural Digest*, June/July, p.48–50.

1999
Wiensowski, Ingeborg, 'Tobias Rehberger', *KulturSpiegel*, June, section 6, p.26.
Gropp, Rosemarie, 'Feldarbeit mit Phantasiemaschinen', *Frankfurter Allgemeine Zeitung*, 31 May, no.126, p.51.
Sommer, Tim, 'Was sich die Kuratoren wünschen', Art. *Das Kunstmagazin*, no.11, November.
Bell Breslin, Ramsay, 'Sunny Side Down', *Express*, 5 November, p.18–19.
Ego, Karin, 'Pflanzen als Kunstobjekte?', *Neue Presse*, 22 September.
Donohue, Mark T.R., 'Garden Variety', *reView: The Arts & Entertainment Section of the Daily Californian*, 3 September.
'[R]ehberger presents Plants as Art', *Westart*, 10 September, p.3.
Gispert-Saüch, Montse, 'Abstracció i decoració', *AVUI*, 6 May, p.19.
R. B., 'La decorazione è femminile', *Il Gionale dell'arte*, April, no.176.
Spiegel, Olga, 'El Centre Tecla Sala muestra los vínculos entre la pintura abstract y la decoración', *La Vanguardia*, 3 March, p.44.
Bosco, Roberta, 'Abstracción y decoración', *El periodico del arte*, no.20, March.
Franzen, Brigitte, 'Garten als Skulptur oder Garten meets Schneekanone', *Kunstforum*, May–June, issue 145, p.110–119.
Smolik, Noemi, 'Tobias Rehberger', *Kunstforum*, July–August, issue 146, p.399–400.

1998
Haye, Christian, plays well with other…. (part two), *Dutch*, spring.
Lind, Maria, 'Raumnachbildungen und Erfahrungsräume', *Parkett*, no.54, p.186–190.
Wulffen, Thomas, et al., 'Berlin Biennale', *Kunstforum International*, January/February, issue 143.
Philips, Christopher, 'Art for an Unfinished City', *Art in America*, January, p.62–69.

Ruthe, Ingeborg, 'Die Lust, sich aufzu-
lösen', *Berliner Zeitung*, 4 January, p.18.
Schwarzenberger, Sebastian, 'Dominanz
des Rechten Winkels', *taz*, 21/22
November.
Wiegenstein, Roland, 'Mönche des
Minimalismus', *Frankfurter Rundschau*,
5 December.
Ebeling, Knut, 'Schlagseite in Richtung
Baupalette', *Tagesspiegel*,
26 November, p.38.
Wahjudi, Claudia, 'Recycling-Kunst',
Zitty, issue 25.
Hilgenstock, Andrea, 'Wer den Kubus nicht
ehrt…', *Die Welt*, 23 November.
N. N., 'Mini-Manismus', *prinz*, 12/98.
Haye, Christian, 'kultur klub', *Dutch*,
no.18, p.27–28.
m. b., 'Schnee und Nudeln', *Salzburger
Nachrichten*, 5 December.
Niegelhell, Franz, 'Symbolische
Architektur', *Neue Zeit*, 4 December.
JP 005 (Model for a Film), exh. cat.,
Moderna Museet Stockholm.
Hofmann-Sewera, Kathi, 'Kommunikative
Kunstverkäufer', *Kleine Zeitung*,
29 November.
Saltz, Jerry, *An Ideal Syllabus*, London.
Birnbaum, Daniel, 'A Thousand Words',
Artforum, November, p.100–101.
Bonami, Francesco, 'Tobias Rehberger',
in: *cream. contemporary art in culture*,
London: Phaidon, p.336–339.
Gorris, Lothar; Wiensowski, Ingeborg,
'Kunst- oder was?', *Spiegel Kultur Extra*,
October.
Nr. 18/1998, exh. cat., Kunsthalle Basel.
Wulffen, Thomas, 'The Berlin Show',
Kunstforum International, October–
November, issue 142.
Posca, Claudia, 'Manifesta in Luxemburg',
Kunstforum International, October–
November, issue 142.
'Manifesta 2 – Ein Fotorundgang',
Kunstforum International, October–
November, issue 142.
Lütgens, Annelie, 'Crossover zwischen
High und Low', *Der Tagesspiegel*, 2/3
October, p.B4.
Reissner, Katja, 'Schöne neue Warenwelt',
Der Tagesspiegel, 2/3 October, p.B3.
Tietenberg, Annette, 'Lustschreie auf der
Rutschbahn der Karriere', *Frankfurter
Allgemeine Zeitung*, 1 October, p.46.
Schröer, Carl Friedrich, 'Grüner Punkt',
Kunstzeitung, August, p.10.
Engler, Martin, 'Fahrradwerkstatt und
Blumenladen', *neue bildende kunst*, 4.
Imdahl, Georg, 'Sisyphos schlägt
Purzelbaum', *Frankfurter Allgemeine
Zeitung*, 4 July.
Engler, Martin, 'Laßt Blumen brechen',
Frankfurter Allgemeine Zeitung,
3 July, p.43.
Rattemeyer, Christian, 'Heute aus der
Gartenabteilung', *Blitz Review*, 2 July.

Wahjudi, Claudia, 'Dezent bis zur
Unauffälligkeit', *zitty*, 13, p.57.
Nemeczek, Alfred, 'Kunst als
Dienstleistung', *Art*, no.5, May, p.26–35.
Stange, Raimar, 'Der Back Stage Boy',
Kunst-Bulletin, 5 May, p.8–13.
Wüstenhagen, Käthe, 'Verblüffend
lebendige und behagliche Effekte',
Mindener Tageblatt, 18 March, p.37.
Queren, 'Warteraum mit knubbeliger
Kunst', *Neue Presse*, 11 March, p.21.
Glanz, Alexandra, 'Die Kunst darf
besessen werden', *Hannoversche
Allgemeine Zeitung*, 11 March.
Decter, Joshua, 'Tobias Rehberger',
Artforum, February, p.93/94.

1997
Kunst… Arbeit, exh. cat, Südwest LB,
Stuttgart, p.58/59, 152/153.
Dziewior, Yilmaz, 'Tobias Rehberger.
Kommunikationskunst', in: *Realisation.
Kunst in der Leipziger Messe*, exh. cat.,
Brigitte Oetker & Christiane Schneider,
Leipzig 1997.
Hixson, Kathryn, 'Tobias Rehberger',
New Art Examiner, March, p.55.
Pesch, Martin, 'Sculpture. Projects
in Münster', *frieze*, issue 36,
September/October.
Enwezor, Okwui, 'Spiral Village', *frieze*,
34, p.82–83.
Söntgen, Beate, 'Die Frau ist die
gefährlichste Waffe der Wohnung',
Frankfurter Allgemeine Zeitung,
1 September, p.40.
Musgrave, David, 'Assuming positions',
Art Monthly, no.9.
N. N., 'Assuming positions', *International
Textiles*, September.
N. N., 'Assuming positions', *D>TOUR*, p.39.
Slyce, John, 'Assuming positions',
What's On, 27 August.
Müller, Silke, 'Das hat Ray nicht verdient',
art, August.
Ebeling, Knut, 'Moderne Möbel als nette
Zitate', *Der Tagesspiegel*, 12 August.
Ebeling, Knut, 'Bitte Platz nehmen!',
Der Tagesspiegel, 19 July, p.21.
Hrsg: Kaspar König, 'Tobias Rehberger',
Fama & Fortune Bulletin, issue 20.
Fink, Wolf-Christian, 'Trautes Heim',
Max, August.
Marschall, Monika, 'Home Sweet Home',
Raumausstatter Zeitschrift, August.
N. N., 'Positions of pretension',
Hampstead & Highgate Express, August.
Feaver, Wiliam, 'Down the pan', *The
Independent*, 25 July.
Feaver, Wiliam, 'Frankly, this place is going
down the pan', *The Observer*, 20 July.
Fischer, Oliver, 'Die Kunst kommt
ins Haus', *Hamburger Morgenpost*,
19 June.
N. N., 'Home Sweet Home', *Architektur
und Wohnen*, no.3.

Hohmeyer, Boris, 'Rückzug in die weiche
Wohnhöhle', *art*, no.6.
Kunz, Sabine, 'Das Innere ist schwer
angeschlagen', *Kieler Nachrichten*,
21 June.
Philippi, Anne, 'Nicht von Pappe',
Süddeutsche Zeitung Magazin, no.20,
16 May.
Schön, Wolf, 'Die Hausfrau ist eine Waffe',
Rheinischer Merkur, 20 May.
Freedman, Carl, 'Things in Proportion',
frieze, March/April, p.66–69.

1996
Kuni, Verena, 'Das Museum als Möbel-
haus', *neue bildende kunst*, 1/97,
February–March, p.44–47.
Dziewior, Yilmaz, 'Tobias Rehberger',
Artforum, January, p.74–75.
Seidl, Claudius, 'Hier blüht Ihnen Kunst',
Süddeutsche Zeitung Magazin, 17 January.
Weh, Vitus, 'Fast nichts/almost invisible',
Kunstforum International, October '96–
January '97.
Stellwaag, Karin, 'Beinahe unsichtbar',
Stuttgarter Zeitung, 7 August.
Voigt, Claudia, 'Tobias Rehberger',
Spiegel Spezial, no.12, p.60.
Herbstreuth, Peter, 'Die normative Kraft
des Schönen', *Der Tagesspiegel*,
16 October, p.26.
Biehler, Matthias, 'Auf der Suche nach
der Kunst', *Südkurier*, 2 July.
Bonik, Manuel, 'Die Kunst zu gewinnen',
stern, no.41, p.124–128.
Pesch, Martin, 'Tobias Rehberger', *frieze*,
July–August, p.69–70.
Karcher, Eva, 'Die Vase ist ein Bild vom
Freund', *art*, 5, p.94.
Herbstreuth, Peter, 'Schauder des
Glücks', *Der Tagesspiegel*, 25 June, p.18.
'Austausch der Sitzkultur', *Der Spiegel*,
no.12.
Wulffen, Thomas, 'Erschöpfte Avant-
garde', *neue bildende kunst*, no.4.
Guth, Peter, 'Don Quichotte zu Besuch bei
Herrn Goethe', *Frankfurter Allgemeine
Zeitung*, 26 June.
Pesch, Martin, 'Gegen die ganz große
Pinselschwingerei', *die tageszeitung*,
2 April.

1995
Pesch, Martin, 'Tobias Rehberger', *artist*,
4, issue 25, p.16–19.
Reissner, Katja, 'Jubiläumsgag', *zitty*,
10, p.51.
Loers, Veit, *Tobias Rehberger*, exh. cat.,
Portikus, Frankfurt; Museum
Friedricianum, Kassel, Cantz.

1994
Joeste, Ingo, 'Tobias Rehberger, Kunst ist
das, was schön aussieht', *taz*, p.62.

This catalogue was published on occasion of the exhibition

Tobias Rehberger, *Private Matters,* at the Whitechapel Gallery, London
10 September – 14 November 2004

THE EXHIBITION WAS CURATED BY
Anthony Spira
ORGANISED BY
Rebecca Morrill with Timandra Reid

THANKS TO
Henry Moore Foundation

neugerriemschneider
Omni Colour
PRICE & MYERS
Sam Forster Ltd

LENDERS
Galerie Bärbel Grässlin, Frankfurt
Galleria Giò Marconi, Milan
neugerriemschneider, Berlin
Frederich Pretzel Gallery, New York
Fondazione Sandretto Re Rebaudengo,
Turin

And those who wish to remain
anonymous.

ACKNOWLEDGEMENTS
Oliver Augst
Lutz Bantel
Anselm Baumann
Rudiger Carl
Sam Forster
Carmen Gheorghe
Bärbel Grässlin
Step Haiselden
Prof. Dr. Med. A. Hellstern
Dr. Med. P. Kardos
Christoph Korn
Tim Neuger
Bob Pain
Tobias Rehberger (the younger)
Burkhardt Riemschneider
Lorraine Sandy
Florian Seedorf
Hartmut R. Schröter
Rirkrit Tiravanija

Whitechapel
80-82 Whitechapel High Street
London E1 7QX, UK
Tel: +44 (0)20 7522 7888
Fax: +44 (0)20 7377 1685

The Whitechapel would like to thank the
following companies, trusts and individuals
whose generosity and foresight enable the
Gallery to realise its pioneering Exhibition,
Education and Public Events programmes.

THE WHITECHAPEL PROJECT SUPPORTERS
The 29th May 1961 Charitable Trust /
Brian Boylan / Antje & Andrew Geczy /
The Glass-House Trust / Richard & Janeen
Haythornthwaite / Brian & Lesley Knox /
Keir McGuinness / Dasha Shenkman /
Tishman Speyer Properties

WHITECHAPEL CORPORATE MEMBERS
Abstract Select / ACE Group / Bloomberg /
Great Eastern Hotel / Lettice / Skidmore
Owings & Merrill (SOM) / Tishman Speyer
Properties

EXHIBITION PATRONS
Shane Akeroyd / Juana De Aizpuru /
Mr & Mrs Marc Embo / Gagosian Gallery /
Goethe-Institut Inter Nationes / KPF /
Lisson Gallery / Luhring Augustine Gallery /
The Moose Foundation for the Arts / Pace
MacGill Gallery / William Palmer / Pepe Cobo
Gallery / Eva Presenhuber / Anthony
Reynolds Gallery / Barbara Weiss / Sylvie
Winckler / Zeno X Gallery / David Zwirner

WHITECHAPEL PATRONS
Heinz & Simone Ackermans / Ivor Braka /
Emanuel Brefin / Francis Carnwath CBE /
Kate Crane & Guy Briggs / Ben & Caroline
Craze / Glen Davis & Mary Jane Aladren /
William de Quetteville / Pierre & Ziba
de Weck / Noam & Geraldine Gottesman /
Robert Graham / Louise Hallett / Hess
Collection / Vicky Hughes & John A. Smith /
Richard Kramer / Sir Stuart and Lady
Lipton / Barbara Lloyd & Judy Collins /
Matthew Marks / Penny Mason & Richard
Sykes / Keir McGuinness / Andrew Mummery /
Maureen Paley / Dominic Palfreyman /
Geoffrey Parton / Richard Pusey /
Alex Sainsbury & Elinor Jansz / Richard
Schlagman / Peter & Flora Soros /
Bina & Philippe von Stauffenberg /
Hugh & Catherine Stevenson / Audrey
Wallrock / Anthony Wilkinson & Amanda
Knight Adams / Anita & Poju Zabludowicz

THE AMERICAN FRIENDS
OF THE WHITECHAPEL FOUNDATION
Marian Goodman / Robin Heller Moss /
Alan Hergott & Curt Shepard / Horace
W. Goldsmith Foundation / Peter & Maria
Kellner / Joshua Mack / William Palmer /
Harry Pollak / Julie Reid / Cecilia Wong /
Michael & Nina Zilkha

WHITECHAPEL ASSOCIATES
Richard Attenborough / Charlotte & Alan
Artus / John Ballington / James M. Bartos /
David & Janice Blackburn / Marlène
Burston / Evelyn Carpenter / John & Tina
Chandris / Swantje Conrad / Louise
Emerson / Bryan Ferry / Winston & Jean
Fletcher / Eric & Louise Franck / Nicholas
Fraser / Edward L. Gardner / David Gill /
Michael Godbee / Piers Gough / Richard &
Judith Greer / Walter Griessman / Lotta
Hammer / Susan Harris / Christoph Henkel /
Jennifer Hirschl & Andrew Green / Pippy
Houldsworth / Andrew Kalman / Jeremy King /
Muriel Lambert / Antony Langdon Down /
Jeremy Levison / George & Angie Loudon /
Lawrence Luhring & Roland Augustine /
Richard MacCormac & Jocasta Innes /
Andrew Marritt / James & Viviane Mayor /
Basil Middleton / Norma Miller / Warren &
Victoria Miro / Dominic Morris & Sarah
Cargan / Frances Mossman / Guy & Marion
Naggar / John Newbigin / William Norman &
Katie Harding / Carlos & Vivian Oyarbide /
Alice Rawsthorn / Michael Richardson / Judi
Ritchie / Karel Roell / Leslie Ross / David
Ryder / Cherrill & Ian Scheer / Kave
& Cora Sheibani / Monika Sprüth / Ian &
Mercedes Stoutzker / Eddie & Euzi Tofpik /
Christoph & Marion Trestler / Helen van
der Meij / Kevin Walters / Wayne Warren /
Andrew Withey

And those who wish to remain
anonymous.

WHITECHAPEL DIRECTOR
Iwona Blazwick

WHITECHAPEL STAFF
Chris Aldgate, Rogerio Bastos, Nicolette
Cavaleros, Beth Chaplin, Jo Dunnett,
Michelle Fletcher, David Gleeson, Annette
Graham, Janeen Haythornthwaite, Geof
Jarvis, Annabel Johnson, Patrick Lears,
Helen Lloyd, Thomas Malcherczyk, Rachel
Mapplebeck, Louise McKinney, Alicia Miller,
Warren Morley, Rebecca Morrill, Zoe
Panting, Faheza Peerboccus, Marilena
Reina, Robert Richardson, Sherine Robin,
Christy Robson, Anthony Spira, Kate
Squires, Candy Stobbs, Andrea Tarsia,
Amy Walker, Sandy Weiland, Simon
Wigginton, Tom Wilcox

WHITECHAPEL INTERNS
Ariel Handleman, Maitreyi Maheshwari,
Irini-Mirena Papadimitriou, Maria Ranauro,
Timandra Reid

CATALOGUE

EDITOR
Anthony Spira

EDITORIAL COORDINATION
Lionel Bovier

DESIGN
Gavillet & Rust

COVER + FLY LEAVES
Tobias Rehberger
Technical drawings for *Me Shell.
As Pumpkin Version* (2004)

EDITING AND PROOFREADING
Clare Manchester

PHOTO CREDITS
Ben Johnson
Anselm Baumann (p.64)
Rebecca Morrill (p.10)

COLOUR SEPARATION AND PRINTING
Musumeci S.p.A.,
Quart (Aosta)

TYPEFACE
Hermes Sans (www.optimo.ch)

© 2004, The authors, the artist, the
photographers, Whitechapel Art Gallery,
JRP|Ringier Kunstverlag AG

PUBLISHED BY
JRP|Ringier Kunstverlag AG
Letzigraben 134
CH-8047 Zurich
Switzerland
T +41 (0)43 311 2750
F +41 (0)43 311 2751
E info@jrp-ringier.com
www.jrp-ringier.com

In co-edition with
Whitechapel Art Gallery.

ISBN 2-940271-46-1
ISBN 0-85488-139-5 (UK only)

JRP|Ringier books are available
internationally at selected bookstores
and from the following distribution
partners:

SWITZERLAND
Buch 2000, Affoltern a.A. (Zurich),
buch2000@ava.ch
FRANCE
Les presses du réel, Dijon,
les.presses.du.reel@wanadoo.fr
UNITED KINGDOM
Cornerhouse Publications
70 Oxford Street
Manchester M1 5NH
T +44 (0)161 200 1503
F +44 (0)161 200 1504
OTHER EUROPEAN COUNTRIES AND ASIA
Idea Books, Amsterdam, idea@ideabooks.nl
USA
D.A.P., Distributed Art Publishers,
New York, www.artbook.com

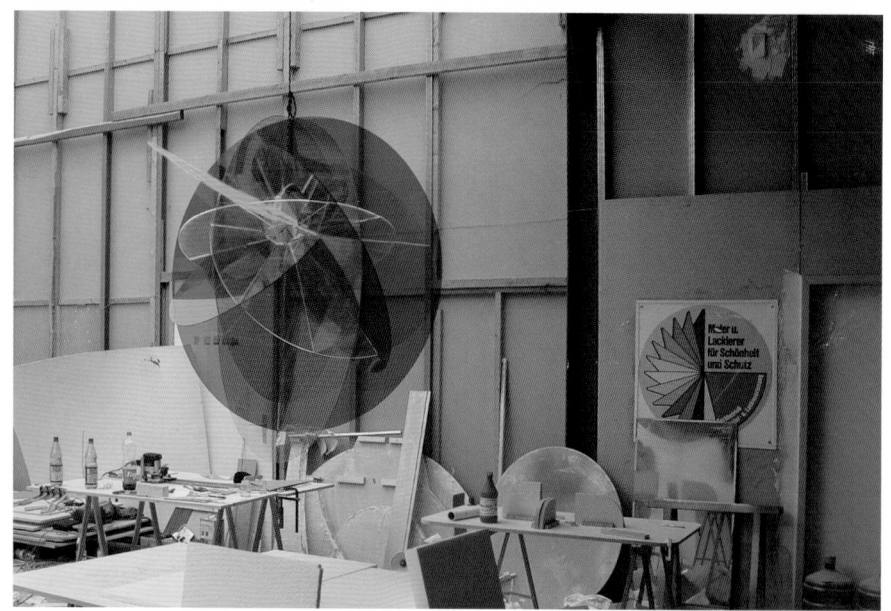